FIRE ISLAND

D1253202

FIRE ISLAND

HEROES & VILLAINS
on LONG ISLAND'S WILD SHORE

Jack Whitehouse

Charleston · London

THE
History
PRESS

Published by The History Press
Charleston, SC 29403
www.historypress.net

Front and back cover images: Photos courtesy of Elaine Kiesling Whitehouse and the Long
Island Maritime Museum.

First published 2011

Manufactured in the United States

ISBN 978.1.59629.859.0

Library of Congress Cataloging-in-Publication Data

Whitehouse, John H. (John Henry), Jr.
Fire Island : heroes and villains on Long Island's wild shore / Jack Whitehouse.
p. cm.
Includes bibliographical references.
ISBN 978-1-59629-859-0
1. Fire Island (N.Y. : Island)--History--Anecdotes. 2. Fire Island (N.Y. : Island)--Biography--
Anecdotes. I. Title.
F127.S9W55 2011
973.91'2--dc22
2011012908

For the best editor in the world: my wife, Elaine.

CONTENTS

ACKNOWLEDGEMENTS

Writing a history book is a long-term project requiring the assistance of many talented people. For a history book with photos, the need for competent research assistance, good photography, meticulous fact checking and trained editing is even greater. So, first of all, I want to thank Elaine Kiesling Whitehouse for her irreplaceable talents in bringing this book to life. As a writer herself and award-winning editor of the *Fire Island Tide Newspaper*, Elaine brought to the book a wealth of experience, creativity and background knowledge quite impossible to duplicate anywhere else.

Many other good people helped me create *Fire Island: Heroes & Villains on Long Island's Wild Shore.* The owner and publisher of the *Fire Island Tide*, Kate Heissenbuttel, is the first on my list of people to thank. Kate's positive spirit and generous nature, combined with her perseverance in the face of any obstacle, provided much of the inspiration to get these stories into print.

Over the years, many excellent writers, historians, mapmakers and military men have contributed to the great body of knowledge available on Fire Island's history. From the earliest explorers with their logbooks and maps, to the nineteenth- and early twentieth-century reporters at papers of record such as the *Suffolk County News* and the *East Hampton Star*, the raw history of Fire Island is there for the finding. Thank-you to them, and thanks also to historians such as William Hawes, Samuel Arden Smith, Edward Shaw, Jeannette Edwards Rattray, Douglas Tuomey, Madeleine Johnson and Harry Havemeyer who collectively ensured that Fire Island's rich history survived in well-documented accounts. These writers deserve great credit for preserving what otherwise might have been lost to us forever.

A special thank-you goes to Librarian Edward "Ned" H.L. Smith III at the Suffolk County Historical Society. Not only is Ned remarkably knowledgeable about our local history, he is also unfailingly helpful to those who ask for his research assistance. We are fortunate to have his irreplaceable expertise. The Suffolk County Historical Society, under the leadership of Director Wallace "Wally" Broege, is a local treasure for its unique collection of genealogies, biographies, periodicals, town records, diaries, photographs, postcards, maps and newspapers. And for those interested in purchasing relevant and hard-to-find books on the subject of Fire Island history, the society's highly knowledgeable administrative assistant, Diane Perry, keeps the society's bookstore stocked with a singularly large collection.

A number of the historical photos included in this book came from the files of Judy Stein and Ken Stein of the Sayville Ferries. The Stein family has been providing ferry service to Fire Island continuously since 1894. Their family and their business have been as much a part of Fire Island and Great South Bay history as any of the fascinating people and events of days gone by.

Special thanks to Barbara Forde at the Long Island Maritime Museum for her extensive knowledge of local maritime history and her quick and able assistance in providing old photographs so helpful in relating these stories.

Sharon Pullen, C.A., the archivist at the Office of the County Clerk, Historic Documents Library, in Riverhead, went out of her way to permit the examination of nearly two-hundred-year-old original inquest documents from the county archives. Her quick, courteous and able assistance is noteworthy and almost certainly appreciated by more researchers than just me.

I must say thank-you to the founder of the *Fire Island Tide*, Warren C. McDowell. Warren is the person who years ago first encouraged my wife, Elaine, and me to write about the history of Fire Island and the Great South Bay. Without his early support, this book would not have come about.

I want to extend my appreciation to the editors at The History Press, particularly Commissioning Editor Whitney Tarella, for their support and encouragement in getting this book completed. A cooperative, working environment created by a good publisher makes the hard tedious work of finishing a book a great deal easier. The History Press is a well-run organization doing a wonderful job of getting local history into mainstream literature.

Thanks to members of the Sayville Historical Society for their input and assistance. Society president Constance Currie, Curator Linda Conron and

Program Chair Suzanne Robilotta are always open to providing assistance with research projects. Special thanks to Linda for her assistance with photos for the Widow Molly story. Thanks also to society member John Wells for his knowledge of the local community and his willingness to share that information.

Rob and Jean DeVito of St. George's Manor made a special effort to provide me with an authoritative review of the history of the property, the buildings and the people who lived there.

The very active and professional Bay Shore Historical Society, particularly members Robert and Priscilla Hancock and Jewell Jacobsen, provided essential and expert detail on the Bay Shore Naval Air Station.

Joe Lachat is a talented photographer who contributes so much to the photographic record of the Fire Island Lighthouse. His photos helped immensely. David Griese, director of the Fire Island Lighthouse, manages a great year-round program, educating the public on the history of the lighthouse and related Fire Island topics. Thanks to him for never failing to respond to questions about the people and events that shaped that part of Fire Island and to putting us in touch with helpful contacts.

Thanks also to L'Anse aux Meadows photographer Paul Ross for his instructive work.

Christopher Bodkin, in his former role as Islip town councilman, went out of his way to afford me the opportunity to review Islip town books and records for information related to the service of so many local citizens in the defense of this country. Chris probably has done more to recognize our veterans than any other local official.

Thanks also go to Superintendent Chris Soller and the entire staff of the Fire Island National Seashore for their combined and continuing efforts to preserve Fire Island and much of the South Shore Estuary for future generations.

Special thanks must also go to next-door neighbor and lifelong Sayville residents Al Bergen and his wife, Lois, for their inspiration.

Finally, I want to thank my son, John III, and his wife, Etsu, for their support and encouragement in completing this project.

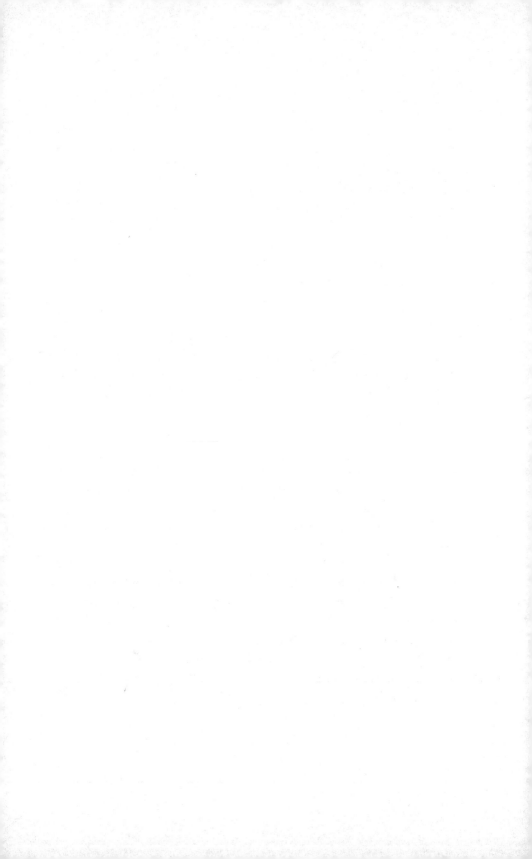

INTRODUCTION

I f you want to learn about real-life heroes and villains of Long Island's South Shore, then this is the book for you. Inside are the true stories of pirates; George Washington's spy chief, Benjamin Tallmadge; U.S. Navy captain David Porter; and Herman Melville.

You will read about some of the most devastating of the hundreds of shipwrecks along Fire Island's shores and the nearly unbelievable rescue attempts of passengers and crew by local heroes.

If mystery is what you're looking for, then you need look no further than the story of the Mystery of Old Inlet. For two centuries, men and women have studied the case of the eleven strong and healthy young men who went to sea on a beautiful Friday afternoon to go fishing and never returned. What destroyed their boat and killed them all on a warm calm late fall evening only a few hundred yards from shore?

Have you ever wondered what created Fire Island and where it got its name? Were the Irish the first to visit, or was it the ancient Norse who explored the east coast? What about Basque and other western European fishermen; did they precede Columbus?

You will discover the almost forgotten contributions of World War I navy men at the Bay Shore Naval Air Station and at West Sayville's Section Base 5 and learn about the heroic things they did in America's effort to win the "war to end all wars."

You will discover secrets that the Native Americans taught the earliest South Shore settlers about catching whales and what Herman Melville experienced that enabled him to write his most famous work, *Moby Dick.*

Finally, you will enjoy the remarkable story of how and why Santa Claus came to fly around the Fire Island Lighthouse.

Reference points on
Long Island, Fire Island
and the Great South
Bay. *Map courtesy of
Elaine Kiesling Whitehouse.*

ound

old Mans

X

Tallmadge
Trail

Lake Ronkonkoma

O

land

netquot River

Sayville

Patchogue
Bay

Bellport
Bay

Fort St. George and
Manor of St. George

uth Bay

outh Beach (Fire Island)

Smith Point

Smiths Inlet
(Old Inlet)

Watch Hill

Fire Island Pines
Cherry Grove
Cunken Forest
woods

WHO DISCOVERED FIRE ISLAND?

Most historians today say that the first European to set eyes on the beautiful white sands of Fire Island was Italian explorer Giovanni da Verrazano (1485–1528). In the spring of 1524, sailing for French King Francis I, Verrazano navigated his ship, *La Dauphine*, along the coast from the mouth of the Hudson River to Rhode Island's Narragansett Bay. His well-documented route took him just off the barrier beaches, including Fire Island. The shoreline Verrazano sailed past looked much like what we see today, except that there was less vegetation—no one knows for certain why—and more and wider inlets. But was Verrazano really the first European to see Fire Island? And if it wasn't Verrazano, then who was it?

The story of today's Fire Island began long before any European visited North America. Approximately twenty thousand years ago, glaciers covering much of North America began to recede. As they retreated, they deposited the boulders, rocks, sand and other material they had gathered during their push south. As the glaciers melted, water flowed back into the oceans, raising the sea level considerably. Scientists estimate that when the glaciers began their retreat, Long Island's shoreline may have been as far as eighty miles south of where it is today.

The rise in sea level became particularly rapid between about 18,000 and 8,000 years ago and then slowed. Scientists believe the barrier islands began to form about a mile south of where they are today. The barrier islands moved northward together with the coastline as the sea level continued to rise. However, this northward movement probably was not slow and steady. The central portion of Fire Island has not moved at all for perhaps as long as the past 1,300 years.

In addition to the effects of a rising sea level on the geomorphology of the barrier islands, in approximately 300 BC, a sudden, significant, high-energy geological event occurred off Long Island's South Shore. The nature of this seismic event remains unclear, but scientists think it may have been a moderate-strength tsunami. A second possibility is that a meteor hit the Atlantic Ocean just off the New York and New Jersey coastline, sending waves of ocean water far inland. A third and more distant possibility is a mammoth storm. But whatever it was that happened, the event left the coast of the South Shore resembling basically what we have today: shallow bays and lagoons behind barrier beaches. Since 300 BC, wind and tidal forces and the occasional significant storm have caused inlets in the South Shore barrier beaches to open and close, narrow and widen; however, the topographical outline of Fire Island and the others have remained basically the same. Thus, whoever the first European was to see Fire Island probably saw something quite similar to what we see today.

Recent discoveries of ancient European texts hint that, as early as AD 520, the Irish may have visited North America, perhaps even sailing past Fire Island. The most well known of such stories is about St. Brendan the

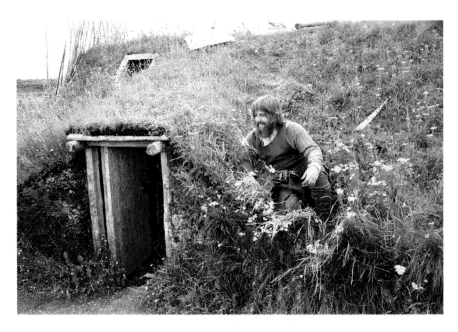

The entranceway to one of the sod house dwellings at L'Anse aux Meadows. *Photo courtesy of Paul Ross.*

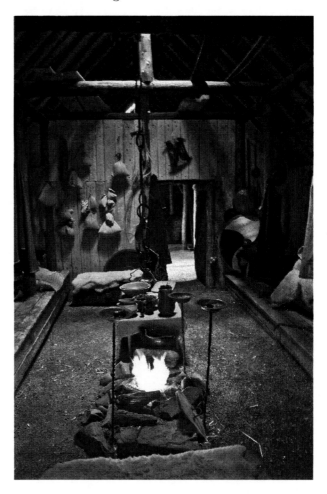

The inside of this sod house dwelling shows what the living quarters were like at Leif Ericsson's camp. *Photo courtesy of Paul Ross.*

Navigator, born in AD 484 near the port of Tralee in the southwest of Ireland. According to the story, sometime between AD 512 and 530, St. Brendan, together with as many as sixty other men, set sail from Ireland on a westerly course in search of the "Isle of the Blessed." After seven years exploring, they finally reached their goal. The Isle of the Blessed was said to be so vast that St. Brendan and his men could not reach its far shore even after forty days of walking. The beautiful verdant land was covered in lush green forest with many fruit trees and a river that was too wide to be crossed.

More than one hundred different manuscripts of St. Brendan's story have been found across Europe; however, the earliest written account yet discovered, entitled "The Voyage of Saint Brendan the Navigator" (in Latin,

the "Navigatio Sancti Brendani"), was made more than three hundred years after the voyage. Previously interpreted as a religious allegory, historians now look at "The Voyage of St. Brendan the Navigator" as possibly based on actual events. Some now postulate that St. Brendan followed much the same route across the Atlantic as did the Norse some five hundred years later. They think St. Brendan's Isle of the Blessed was in North America, and that details in "The Voyage of St. Brendan the Navigator" prove that the Irish monk was the first European to reach the North American continent.

The idea that St. Brendan may have visited the New World is not as farfetched as first it might seem. The Irish of the time routinely went on long sea voyages and related those events in what they called *immrams*. These sea stories involved a hero's adventures at sea, some of them describing visits to a legendary island far to the west, beyond the edges of any known map of the time.

Another piece of evidence of an early visit by the Irish to North America is the ancient stone construction located in Groton, Connecticut. "Gungywamp," as the one-hundred-acre site is called, was built over many centuries, possibly beginning millennia ago. In the 1960s, scientists suggested that at least some of the Gungywamp construction is similar to structures from medieval Ireland. Finally, there is the fact that, prior to his voyage in 1492, Christopher Columbus studied manuscripts providing details of St. Brendan's quest.

However, scientists and historians agree that, without the discovery of any hard evidence of early Irish travel, it is not possible to assert that St. Brendan or any other Irishman visited North America before the Norse. Certainly there is a good deal of circumstantial evidence about medieval Irish travel to North America, but proof remains elusive.

Long before Christopher Columbus, and not long after St. Brendan, were the now proven Western Hemisphere explorations of the legendary Norse. Better known for their bloody raids into civilized Europe, the Norse, or the Vikings as they are also called, established trade routes in the waters of the far north. Similar to the Irish immrams, the Norse made written record of their sea-faring adventures; the Norse did it in detailed documents called the *sagas*.

According to the sagas, in AD 986, a Norse explorer and merchant named Bjarne Herjolfson ran into a fierce Atlantic storm while trying to get from Iceland to Eric the Red's settlement on the southwestern coast of Greenland. The storm drove Herjolfson's longboat far to the west, close to a

heavily wooded shore that scholars today believe was probably the northern coast of Canada's province of Newfoundland and Labrador.

The lost explorer and his boat survived the storm and eventually made it to Greenland. Herjolfson described his accidental journey and discovery of a new land to all who would listen. Leif Ericsson, the then teenage son of the infamous Eric the Red, took note, and years later in about 1001, gathered an expedition to retrace Herjolfson's route.

The sagas say that on his initial voyage, Ericsson and his longboat crew of about fifty men discovered three separate areas on the North American continent. He named them as follows: Helluland, meaning "land of the flat stones"; Markland, or "forest land"; and Vinland, meaning "wine land." The precise location of the three areas has always been unclear; however, many historians identify Helluland as today's Baffin Island and Markland as Labrador. But Vinland remains a bigger question.

Historians know Ericsson named Vinland for its bountiful wild fruit, particularly wild grapes and other such species easily converted into alcoholic drink. So Vinland almost certainly lay south of the Gulf of St. Lawrence, the approximate northern limit for such plants at that time. Many scholars believe that Nova Scotia, the states bordering the Gulf of Maine and those regions as far south as the bays of New York, might well have been part of Vinland.

In 1960, archaeologists unearthed the Norse settlement at L'Anse aux Meadows on the northern tip of the island of Newfoundland, proving that Leif Ericsson and other Norse that followed him had been at least that far south. They discovered that the camp once housed as many as 135 men, 15 women and a variety of livestock. Archaeologists believe the Norse inhabited the site for several years, perhaps much longer, suggesting that the Norse probably had more settlements, even farther south and west, that have yet to be uncovered. In the 1960s, another Norwegian researcher, Johannes Tornoe, suggested Waquoit Bay, located on the south shore of Cape Cod, might well be the location of another Norse settlement. Just within the past fifty years, a growing body of evidence shows that these ancient explorers probably traveled as far west as Minnesota, through the St. Lawrence Seaway and the Great Lakes, and as far down the East Coast as the mouth of the Hudson River.

A look at Atlantic Ocean currents shows how easy it would have been for a Norse longboat to travel from L'Anse aux Meadows to New York Bay and the mouth of the Hudson River. The Labrador Current runs down the west

side of Newfoundland to the mouth of the St. Lawrence River and then basically carries south all the way to Montauk Point, along the coast of Fire Island to New York Bay. Leif Ericsson's longboat, traveling with a favorable wind, might have easily logged ten to fifteen knots per hour, so the voyage to New York harbor would not have taken all that long. Indeed, they may have made the trip several times, possibly stopping on Fire Island for fresh water (it is plentiful), to gather food (all manner of fish, shell fish and game) and to spend the night in relative safety from any possible Native American attack.

What is the other evidence of ancient Norse travels in this area? A Norse penny found in 1957 at a significant Native American archaeological site in Penobscot Bay, Maine, has been authenticated as a Norwegian coin minted sometime between AD 1065 and 1080. There are also the so-called rune stones—flat slabs of stone on which ancient Scandinavian letters, or runes, were carved. The Norse left these in new places where they visited as proof and record of their visit. Many rune stones have been found on the New England coast, including that of the Long Island Sound. Of all the stones found, only one has been proven a hoax.

In their travels, the ancient Norse used hand-held drop lines to catch the plentiful codfish. Dried, smoked or fresh cod provided much of their diet. Certainly the ready availability of cod and other species off the northeast coast of the United States would have eased the hardship of Leif Ericsson's and his Norse successors' exploratory travels throughout the area. Norse accounts of a grand abundance of fish, shellfish, birds and other game probably spread even to the other European peoples who fished the Atlantic, thereby encouraging their travel farther west.

While historians strongly suspect Basque, Breton, Norman and English fishermen fished the Grand Banks and surrounding waters not long after the Viking period, definitive proof of these early voyages to the North American continent have yet to be discovered. To date, the earliest reliable records are from the early sixteenth century. For example, we have written proof that a Frenchman named Jean Denys from Honfluer, a port at the mouth of the Seine, fished the Grand Banks as early as 1504. Other records show that Thomas Aubert of Dieppe, another French port on the English Channel, visited there two years later. In 1507, a Norman fisherman returned to Rouen with an extra cargo of seven *sauvages* who were probably Beothuk Indians. The Beothuk were the native inhabitants of the island of Newfoundland in the sixteenth century and before.

Then there are also the voyages of Giovanni Caboto, aka John Cabot (circa 1450–1500), the Italian navigator and explorer. In the summer of 1497, in his ship *Mathew*, Cabot claimed to have "discovered" North America for King Henry VII of England. While the best guess today is that, in the summer of 1497, Cabot landed in Newfoundland, turned around and sailed straight back to England, it is possible he landed farther to the west. Then, in 1498, Cabot left Bristol, England, with five ships on a second expedition to North America. Unfortunately, little record of this second expedition exists; there is no proof of where Cabot landed in North America, how far down the East Coast he traveled or even if he managed to return to England. However, there is some evidence that, in the spring of 1500, at least some of his expedition made it back to England, following a two-year exploration of North America's East Coast. There is also some evidence that Giovanni Antonio de Carbonariis and other friars who were part of the second Cabot expedition actually established a religious colony in Newfoundland. Did they see Fire Island? Did they visit New York Harbor? We may never know.

While scientists continue to work on finding undeniable proof of early European travel to the New York area, including Fire Island, we know enough to be encouraged that one day such proof probably will be found. Today an educated guess as to who was the first European to see Fire Island must include an early Middle Ages (circa fifth to tenth century) Irish explorer, the ancient Norse or an early second millennium west European fishermen or explorer.

Thus Giovanni da Verrazano, the man credited in the history books with seeing Fire Island for the first time, almost certainly saw it and the surrounding area hundreds of years after the first European to do so. But Verrazano was the first to have the good sense to make detailed record of his observations, and so he remains our official discoverer—at least for the time being.

HOW FIRE ISLAND
GOT ITS NAME

M any wonder how Fire Island came by its intriguing name. While no one knows the answer for certain, history provides some interesting theories, a few entertaining hypotheses and, if you look deeply enough, some very good clues.

The story begins in 1602 with the government of the Dutch Republic looking for a company to find a new route to the resource and spice rich ports of South East Asia. The Dutch decided the Vereenigde Oostindische Compagnie (the United East India Company) had what they were looking for and chartered the firm to find the fabled western passage to the Indies. The Dutch were eager to find a new route to replace the long and difficult sail around the African Kaap die Goede Hoop (Cape of Good Hope). Thus in 1609, Henry Hudson, an Englishman working for the Dutch, sailed his ship De Halve Maen (the Half Moon) into what are now the bays of New York and up the Hudson River. He found no new route to the Indies, but New York City had been "discovered."

While probably disappointed with Hudson's failure to find a passage to the Indies, the industrious Dutch recognized the profit potential in the rich farmland and plentiful wildlife Hudson had found. Succeeding Dutch voyages to exploit these new resources began almost immediately.

In the early winter of 1614, the Dutch captain Adriaen Block, already on his fourth voyage to the territories discovered by Hudson, founded the earliest Dutch settlement in the New World. His settlement came quite by accident. Block's ship, the *Tijger*, while moored at the southwestern tip of Manhattan, suffered a fire and burned to the waterline. The Dutchmen were forced to set up camp in lower Manhattan, probably on the banks of the

Hudson River, not far from the site of today's Freedom Tower. The Dutch settlement of the New World had officially begun.

To Block and his men's good fortune, the native Lanape Indians with whom Block had been trading agreed to help the stranded men construct a new ship using parts salvaged from the *Tijger*. Their combined efforts produced a sixteen-ton ship, forty-two feet in length, which they named *Onrust* (*Restless*), the first ship ever constructed in the New World. With the ship's completion, Block and his men were ready to abandon their Manhattan settlement.

In the spring of 1614 the *Onrust* set sail from the tip of Manhattan, proceeding up the East River through the fast and turbulent narrows they called Hellegat (Hell Gate). From there the little ship proceeded east, exploring along the coastline of Connecticut. In the process, Block proved that Long Island was an island. He also accurately charted the much smaller island that today carries his name. Finally, he preserved his findings on a map of his own creation, the first time this area had been accurately charted. Block never returned to the land he called New Netherland, but as we know, many settlers followed in his footsteps.

As the seventeenth century progressed, Dutch settlers, sailors, fishermen and traders spread out in all directions from the Hudson River and New York harbor. As late as 1673, the Dutch controlled New Netherland with New York City named "New Orange." It was not until after the third Anglo-Dutch War and the signing of the Treaty of Westminster in November 1674 that the city permanently returned to English rule and the name reverted to New York. By the mid-1600s, travel by the Dutch along the south shore of Long Island became fairly common, and it was then that the Dutch probably gave Fire Island Inlet—an important deepwater entrance to the western Great South Bay and central Long Island—a name reflecting its most prominent feature. At the time, four small islands were located in the approximate middle of the inlet. It makes sense that the Dutch would have made reference to the location as the "Four Islands" (Fier Eylant) and the "Four Island Inlet" (Fier Eylant Inlaat or Fier Eylant Inham).

By mid-seventeenth century, with the arrival in the New York area of increasing numbers of non-Dutch nationals, including many British, the English language became more common if not yet predominant. *Newsday* cites Eric Nooter, a Dutch-born historian, who says, "The Dutch language could be heard on Long Island until the time of the Revolution. Meetings were conducted in Dutch, some church services were in Dutch, and many of the residents were bilingual,

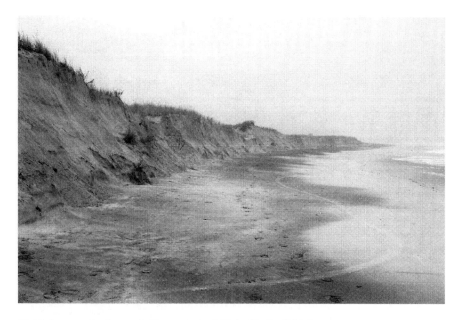

Dutch footsteps in the sand. *Photo courtesy of Elaine Kiesling Whitehouse.*

The Atlantic Ocean shore near the Fire Island Inlet. *Photo courtesy of Elaine Kiesling Whitehouse.*

speaking English and Dutch." Indeed, Dutch was spoken in several locations on the South Shore of Long Island well into the twentieth century.

Today many historians point to the New York area's gradual Germanic language shift from Dutch to English as being responsible for changing the inlet's name from the Dutch Fier Eylant Inlaat to the English "Fire Island Inlet." They cite numerous examples of where the New York–area British settlers slowly adapted Dutch words and names into spoken and written English. A few examples of Dutch words modified into familiar English names for local places and things include the following:

- bay (*baai*, meaning bay)
- bowery (from *boerderij*, meaning farmland)
- Brooklyn (from the Dutch town of Breukelen)
- Bronx (from the Dutchman Jonas Bronck)
- Coney Island (from Konijnen Eylandt, meaning rabbits' island)
- Flat Bush (from *vlade bosch*, meaning thick woods)
- Flushing (from the Dutch port of Vlissingen)
- Harlem (from the Dutch city of Haarlem)
- Arthur Kill, Fishkill, Schuylkill, etc. (from *kill*, meaning river or canal)
- Long Island (from Lange Eylandt)
- Rhode Island (from Roodt Eylandt, so named because of the reddish color of the soil)
- Staten Island (from Staaten Eylandt)
- Yankees (from Jan Kaas, which translates to John Cheese, originally a disparaging nickname for a Dutchman)

With these examples, it is easy to see why many people support the theory that the name Fire Island Inlet came from the Dutch. Also, English speakers looking at early Dutch maps probably pronounced the Dutch word "*fier*" as though it were English, pronouncing it "fire." In fact, one of the oldest-known maps to focus on the area in question, the Wheeler map of 1790, almost proves this point.

Fire Island historian Douglas Tuomey, writing in the March 1959 *Long Island Forum*, explained that in 1790 a surveyor named Samuel Wheeler was commissioned to conduct a survey of the township of Islip and adjacent land, including what is today known as Fire Island. Wheeler's English-

language map is signed and dated "Islip January 1, 1798." Clearly visible on Wheeler's map, in the approximate center of the inlet, are four small islands labeled "Fier Islands." Also clearly labeled is the inlet, identified as the "Great Fier Island Inlet."

Regarding the possibility that Wheeler misspelled the word "fire," Lavern A. Wittlock, in an article for the *Long Island Forum* of September 1973, argues that the entire Wheeler map reflects its creation by a well-educated man, which would preclude any misspellings.

The name Fier Island Inlet and Fier Islands does not appear, at least in English language cartography, prior to the Wheeler map of 1798. However, Madeleine C. Johnson, in her book *Fire Island 1650s-1980s*, says the name Fire Island Inlet had come into use by September 15, 1789, "for in a deed of that date, Henry Smith of Boston sold to some Brookhaven residents beach property running from the Head of Long Cove to Huntting East Gut (Gut being the English version of the Dutch word *gat* meaning gate or opening) or Fire Island Inlet." Indeed, it seems entirely possible that the spelling of the word "fire" in the 1789 English language deed may have been one of the first examples of the shift from the Dutch "fier" to the English word "fire."

Some evidence exists that suggests that in the seventeenth century there were five small islands in the inlet, not four, and that the word "fire" comes from a misreading of the translation of the Dutch word *vijf*, meaning five. In other words, a cartographer misread the translation of "Five Islands" as "Fire Islands." However, the vijf explanation seems less plausible than the fier, first for the reasons described above and also because cartographers making new maps would have had to repeatedly make the same mistake of representing vijf as "fire" and not "five."

Another intriguing possibility is that the names Fire Islands and Fire Island Inlet derive from the Dutch word *vuur*, meaning fire. A slurring of this word could conceivably sound like the English word "fire." However, there exists no known map, deed or other written reference that uses this Dutch word, vuur, to describe these locations.

It is interesting to note that the Great South Beach—a name by which the barrier beach is still officially known to this day—did not gain the name Fire Island until long after the inlet became known as Fire Island Inlet. In fact, it seems probable that, after the first lighthouse was erected on Great South Beach in 1825 that marked the location of the Fire Island Inlet, the island on which it stood gradually became known as Fire Island.

Madeleine C. Johnson writes in her book that the name Fire Island Beach is on a navigation chart from 1851, and from that year on, Fire Island Beach and Great South Beach were "variously used." About 1920, the name Fire Island began to take over; today it is the generally accepted name.

There exist a number of other, more romantic explanations of how Fire Island came by its name. Local historian Douglas Tuomey relates a story that he says was popular at the dawn of the twentieth century: in approximately 1770, the then royal governor of New York, pressured to do something about the loss of ships to grounding on the sand bars off the inlet at Great South Beach, contracted with a local band of Native Americans to keep fires burning on the four islands located in the inlet. However, there appears to be no known written record to support this contention.

Another theory is that, during the whaling season, rows of large fires could be seen from the mainland burning under big cauldrons used to reduce the whale blubber to oil. Similarly, on Fire Island Native Americans used fires to warm themselves as protection from predators and to signal their locations to friends and family on the mainland during hunting trips. Native Americans and early settlers on the mainland would have noticed such bonfires on the beach and might well have made regular reference to the place as Fire Island. However, we know the local Native Americans did not associate their word for fire with Fire Island. They called it Seal Island after the large numbers of these marine mammals that rested on the beach during their seasonal migrations. Even today, with a greatly diminished East Coast seal population, in winter it is not unusual to find seals lying on the ocean beaches, sunning themselves.

Lending credence to the theory that Fire Island got its name because of the fires is a story from the Long Island hamlet of Brookhaven, not to be confused with the town of Brookhaven, in which the hamlet is located. Prior to 1871, Brookhaven hamlet, bordered on the south and east by the Great South Bay and Carman's River, was named Fire Place. It is believed to have been so named because of the fires that were set there to guide ships through Old Inlet—Smith's Inlet at the time.

Perhaps the most romantic notion of all is that Fire Island came by its name from the work of land pirates, sometimes referred to as professional wreckers. Cherry Grove's Jeremiah Smith is recognized as the most infamous of them all. In poor weather, the wreckers built large fires east of the inlet to lure ships onto the bar in order to kill the crew and plunder the valuable cargo.

Finally, one of the more original theories as to how Fire Island got its name derives from the numerous ways a person can return from a visit feeling as though he or she is on fire. An unwary visitor may need to contend with the nasty problems of sunburn, poison ivy, poison sumac, jellyfish stings, ravenous mosquitoes, horse and black fly bites and scalding summer sands.

Thus, while the origin of the name Fire Island remains something of a mystery, the evidence appears to point to the language of the courageous Dutch explorers—men like Henry Hudson and Adriaen Block, who in the early 1600s paved the way for everyone else. For the Dutch it was their Golden Age, their culture at its peak, the artist Rembrandt van Rijn (1606–1669) at his best. Only four hundred years ago, such Dutchmen were making it possible to create the civilization we enjoy today, including the place we now know as Fire Island.

CAPTAIN KIDD'S
FIRE ISLAND TREASURE

W e know that the pirate, Captain William Kidd (1645–1701) buried treasure on Gardiner's Island, the little island lying between the two forks at the east end of Long Island. In late June 1699, Kidd and a few of his most trusted men buried at Cherry Harbor a fortune of gold dust, diamonds, rubies and other precious and semi-precious gemstones and bars of silver. According to Jeanette Edwards Rattray, local historian and longtime columnist, editor and publisher of the *East Hampton Star*, Kidd stayed on the island for three days. When he left, he promised to return for the treasure, threatening the island's owner, John Gardiner, with death, or the death of his son, if his treasure were to go missing. But despite the threats, the sturdy bags and great wooden chests of gold, silver and jewels were destined not to stay buried for long.

On July 6, 1699, within days of the treasure's burial, Kidd's one-time friend and business associate, Richard Coote, the Earl of Bellomont and colonial governor of New York and Massachusetts, had Kidd arrested and thrown into prison. The fifty-four-year-old Captain Kidd would never know freedom again.

Only three weeks after Kidd's imprisonment, Governor Coote ordered John Gardiner to recover Kidd's treasure and bring it to Boston. The official inventory of items recovered—a copy is in the East Hampton library—included 1,111 ounces of gold, 2,353 ounces of silver, about a pound of cut gems and a variety of other valuable items. Eventually Governor Coote saw to it that Kidd's treasure got shipped safely back to the Royal British Treasury in London.

What has remained a mystery to this day is whether Captain Kidd buried any additional treasure, and if so, where? Circumstantial evidence, including

a study of the man, his character and his family life, suggests that in the spring of 1699 he probably did hide some of his treasure somewhere other than Gardiner's Island. But where would he have buried it? The answer is the desolate and isolated south coast of Long Island, probably somewhere between today's barrier beach villages of Ocean Beach and South Hampton. The following explains why this is the case.

For the first fifty years of his life, Captain William Kidd enjoyed a reputation as a man of intelligence, honor and courage. He loved the sea, and from his earliest days as an apprentice seaman, he aspired to command his own ship. In 1689, while in the Caribbean and after crewing on numerous trading ships and pirate-chasing vessels, Kidd realized his life's goal of command at sea. He became the captain of the twenty-gun brig *Blessed William*. But his tenure as captain lasted only briefly; a mutinous crew stole his ship, leaving him high and dry on a Caribbean island. The governor of the island, sympathetic to Kidd's plight, provided him with a captured French vessel together with a crew sufficient in size to allow Kidd to go in pursuit of the stolen *Blessed William*. Captain Kidd managed to chase his old ship as far as New York City where, in the crowded wharves and anchorages of the busy harbor, the trail went cold.

But Kidd's reputation as a brave and clever sea captain had preceded him to New York. City leaders welcomed him, inviting him to a variety of official and unofficial programs and affairs of city society. At one such event in 1690, he made the acquaintance of the beautiful and wealthy Sarah Bradley Cox Oort. At the time of their meeting, Sarah was the wife of Mr. John Oort, a prominent businessman who owned several busy docks and much of what is now Wall Street, including a comfortable house at 56 Wall Street. Not in Kidd's nature to allow Sarah's marriage to stand in the way of a deepening relationship, Kidd visited Sarah as often as possible.

Knowledgeable New Yorkers described Sarah and Kidd as an odd match. She was beautiful, married and wealthy, and he was relatively poor and, at the age of forty-five, not a dashing handsome fellow to anyone's way of thinking. In fact, Kidd was said to have plain brown eyes, a longish nose, lips that seemed to curl at the edges, a quick temper and a penchant for wearing a dusty, ill-fitting shoulder-length wig. On the more attractive side, he was tall and liked to dress well; he was also intelligent, self-educated and more well read than most. He possessed a wit described by those who knew him as even quicker than his temper. Whatever the combination of his personal

characteristics, Sarah seemed to be captivated by the whole package and, by all accounts, fell deeply in love with him.

A number of historians say that the mysterious death by drowning of Sarah's husband, John Oort, only two days before Kidd and Sarah applied for a marriage license points to the strong possibility of homicide. Some even go so far as to suggest that Sarah helped Kidd murder her wealthy husband. But the authorities of the day found no evidence of any wrongdoing by either Kidd or Sarah, and so the marriage of the lovely Widow Oort to Captain William Kidd went ahead as planned on Saturday, May 16, 1691. Thus at the age of forty-six, pirate chaser Captain William Kidd suddenly found himself a land-bound but wealthy married man with two children and several profitable New York businesses to manage. By all accounts, he was a devoted husband and father, doting on Sarah's young daughters.

But thrill-seeking Captain William Kidd could not completely adjust to life as a businessman, family man and gentleman of society. Only four years after his marriage to Sarah, at the age of fifty, Kidd decided he had to go back to sea and do what he did best—track and kill pirates. So, with Sarah's blessing, Captain Kidd went to London to seek either a commission in the Royal Navy or command of a privateer.

In 1695, he arrived in London where he met his eventual nemesis, the wealthy and well-connected Richard Coote, the Earl of Bellomont, a recent appointee to become governor of Massachusetts, New Hampshire and New York. As his primary mission, King William III had instructed Bellomont to suppress the rampant piracy and smuggling ongoing in the coastal areas of New York and Massachusetts.

With his assigned counterpiracy duties in mind, the Earl of Bellomont decided to help arrange for Kidd to become a privateer dedicated to hunting pirates and their treasure. Thus, on December 10, 1695, the British admiralty granted Kidd a privateer's Letter of Marque, and on January 26, 1696, King William III ordered Kidd to go forth and hunt pirates on the high seas. The one caveat clearly imposed by King William was that, at his extreme peril, Kidd was not to "in any manner, offend or molest any of our friends or allies, their ships or subjects."

In the late winter of 1697, about one year after receiving his orders from the king, Kidd departed England aboard his new gun ship, the *Adventure Galley*. The ship carried some thirty canons and a crew of more than eighty men. But the voyage to the Indian Ocean and the busy trade routes around

the island of Madagascar did not go well from the start. During the trip, a third of his crew died from an outbreak of cholera, and the ship developed a significant number of leaks that proved near impossible to plug. Worst of all, Kidd had difficulty finding any suitable non-British targets. His crew became increasingly discontented, focusing on what they perceived to be Kidd's lack of aggressiveness, his poor luck (good luck was considered an important attribute for a sea captain) and the absence of any profitable activity.

Things came to a head on October 30, 1697, when William Moore, one of Kidd's gunner's mates, confronted him on the main deck. He loudly accused Kidd of not being aggressive enough against a potentially profitable Dutch ship and blamed him for bringing ruin to the entire crew. Captain Kidd lost his temper, and while screaming at Moore, he picked up an iron-bound bucket and smashed Moore over the head with it, knocking the poor man out cold. Moore, bleeding profusely from the head wound, died the next day of a fractured skull.

The incident caused resentment within the crew, approaching open hostility, and thus, probably out of fear of losing control of this ship as he had the *Blessed William*, Kidd changed his tactics and began attacking virtually any vessel that hove into sight. Virtually overnight, in the eyes of the civilized world, pirate hunter Captain Kidd had become the evil pirate Captain Kidd.

In January 1698, Kidd and his crew captured their biggest prize, the *Quedah Merchant*, a huge and well-armed treasure ship. But the ship belonged to the British East India Company, and its capture sealed Kidd's fate as a marked man on the run. The big ship became Kidd's new vessel, replacing the leaking and worn out *Adventure Galley*. Kidd renamed his new ship the *Adventure Prize*.

Despite the more aggressive activity, his crew remained unhappy with him. In June 1698, while sitting at anchor in the pirate-infested port of Sainte Marie in Madagascar, Kidd lost most of his men through defection to other pirate vessels. As time passed and without the prospect of regaining much of a crew, Kidd decided he had had enough—it was time for him to leave the west African coast and return to New York. Thus, by November 1698, with a barely sufficient number of men on board to sail the ship, he set course for the Spanish Main.

In March 1699, the *Adventure Prize* arrived at Anguilla in the West Indies. It was here that Kidd and his crew received the shocking news that the British government had declared them pirates. Out of fear of capture, the

crew, except for a few men, abandoned ship. Kidd, however, was convinced that there was some mistake and decided he wanted to prove—or buy—his innocence. But Kidd was no one's fool, and so he decided to take significant precautions for his return to the New York area.

Kidd realized he would risk near-certain capture if he sailed the well-known *Adventure Prize* north, so Kidd left the big ship behind. He purchased a small sloop named the *St. Anthony*, quietly transferred his treasure onto it and, unnoticed, set sail for the north. The next reported sighting of the *St. Anthony* did not come until June 9, 1699, when the little sloop anchored in Oyster Bay on the north shore of Long Island.

From Oyster Bay, Kidd immediately sent secret messages to his wife, Sarah, and his lawyer, James Emott. He instructed Emott to go to Boston and negotiate with Governor Bellomont about a possible pardon. He asked Sarah to come and join him aboard the little sloop *St. Anthony* to celebrate a reunion after four years apart. Sarah, still in love with her sea captain, went almost immediately.

After hearing from Emott and before sailing to Boston for what he thought would be discussions with Bellomont, Kidd decided to stop at Gardiner's Island to bury his treasure. Gardiner's Island would be the perfect place to safely store his vast ill-gotten wealth. If need be, it could be quickly retrieved either as a bribe for Bellomont, or it could be safely left there for as long as necessary.

However, arriving in Boston, William and Sarah Kidd found themselves immediately arrested and thrown into prison. While Sarah was quickly released, she would never again see her husband and the love of her life.

Bellomont promptly shipped Kidd off to London where, after a show trial in the British House of Commons, he was found guilty of murder and piracy on the high seas. On May 23, 1701, Captain William Kidd was hanged for his crimes at the execution dock in Wapping outside London. He was actually hanged twice, as the rope broke during the first attempt. Adding insult to injury, after the second, successful hanging, Kidd's body was tarred, placed in an iron gibbet and hung over the Thames River at Tibury Point for all to see.

What is missing in Captain Kidd's otherwise well-documented history are the details of his long weeks of travel aboard the sloop *St. Anthony* from Anguilla to Oyster Bay. We know the small sloop had to stop often along the way for fresh water and provisions and that Kidd was very concerned about being recognized and arrested if he put into a large port. He also would have been concerned about any possible intrusion that would reveal the fortune in treasure he was carrying in his small, almost unarmed boat.

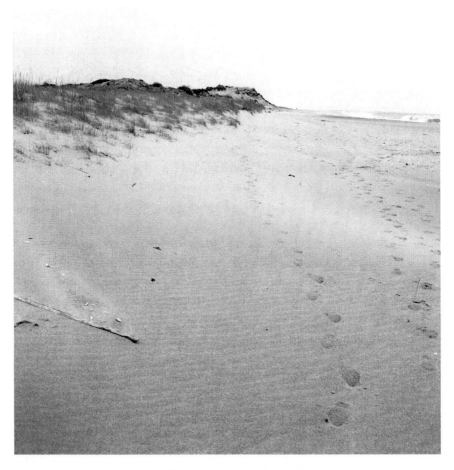

A high dune such as one Captain Kidd may have used to mark the location of his treasure. *Photo courtesy of Elaine Kiesling Whitehouse.*

We also know Kidd was familiar with the east end of Nassau Island (the name for Long Island at the time) and the desolate and isolated barrier beach, which we know today as the Great South Beach or Fire Island. He, and probably his men as well, knew the beaches, bays and inlets that Governor Bellomont called this "great receptacle for pirates." In a letter to London

dated July 22, 1699, Bellomont actually wrote in reference to Brookhaven and the barrier island, "and yet that end of the island is at present their [the pirates] rendezvous and sanctuary."

From the earliest days of the nation, the people living near the South Shore of the east end of Long Island believed it their right to take any and all properties found on the ocean beach, regardless of origin or ownership. Early on this larcenous tradition gave rise to men and women known as "land pirates" who made it their occupation to lure unsuspecting ships to ground on the beaches where their crews might be killed and their cargo stolen. Burying treasure on this remote and lawless barrier beach was not an uncommon activity.

What may well have happened is that Kidd sailed his little sloop up the East Coast with the intention of stopping in a secluded and unobserved location on Long Island's Great South Beach before rounding the east end of Long Island and proceeding west to anchor in Oyster Bay. On the barrier beach, he could obtain fresh water and food supplies without fear of being noticed or approached by authorities, and most importantly, he might safely bury some of his treasure. Kidd probably reasoned that he had to keep most of his treasure for use as a bargaining chip with Governor Bellomont to secure his pardon. This was the treasure he buried on Gardiner's Island, riches that could be quickly and easily dug up and brought to Boston to bribe Bellomont. But he would leave a significant stash of riches safely buried on the Great South Beach, where one day he might return and claim it.

Kidd also wanted to provide for Sarah and to give her the things that he had fought and risked so much to obtain. So when she visited him on the little sloop in Oyster Bay, he told her where the barrier beach treasure was buried. But poor Sarah had no wish to be a part of such things—she was wealthy in her own right—and after Kidd's arrest and return to London for trial, she left Kidd's unneeded fortune where it was, never to be disturbed.

We know Sarah and her daughters moved north of New York City, where Sarah eventually married for a fourth time. However, it was said that she remained forever loyal and in love with her third husband, Captain Kidd. Now all we have to do is find out where on Fire Island he buried Sarah's treasure.

Chapter 4

THE ROYAL FISHES

Whaling on the American East Coast occurred centuries before the arrival of the white man. Native American tribes on the South Shore of Long Island hunted and killed the right whales (*powdawe*, in Algonquian, meaning whale hunt) that swam in the shallow waters close to the shore. Riding the breakers in dug out log canoes, armed only with bow and arrow and light wooden lances tipped with sharpened bone, the Indians attacked their slow-moving prey. Sometimes they would use their fleet of canoes to drive the whale into shallow water where it might be more easily killed. In deeper water, they harpooned the whale, and when he came up after his dive to escape, they shot as many arrows into him as they could to make the creature bleed to death.

With the whale dead or nearly so, the Indians towed their prey to the shallows. Once beached, the women, children and older men would begin the laborious slaughtering process, using knives and hatchets. Oil boiled from the blubber had many uses. It was an ingredient in dishes of corn and peas. The Indians used the whale oil and raw grease from the blubber as a preservative and as water proofing for their leather clothing and other leather goods. In later years, they often harvested just the tail and fins, leaving the rest of the animal to the scavengers and to rot. They roasted the meat from the tail and fins and often offered some of it as a tribute to Indian deities.

There exist no records of the losses suffered by the Native Americans in their pursuit of these leviathans, but surely men died. A typical adult right whale is fifty feet in length and weighs about fifty tons. The flukes of such a whale are twenty feet across. The damage such a large and powerful creature can inflict when angered is substantial. Furthermore, whaling was a wintertime event, from roughly November to April, which meant the Indians

took to the seas in their small open dugouts in harsh weather conditions. A glancing blow from a tail fluke or even a hit from the wake of a whale trying to escape could easily knock the hunters into the frigid water.

Early settlers who observed Indian whale hunts commented that the dugouts often capsized, but that the Indians were remarkably good swimmers and adept at righting their craft. What protection the Indians used against the cold wind and water is unclear, but it must have been remarkably effective. Unprotected immersion in frigid water, even for a healthy swimmer, can quickly bring about death from hypothermia. While the colonists knew the dangers of providing Native Americans with hard liquor, in 1672 they made a special dispensation for providing a limited amount of "licker" (usually rum) to Indians employed in catching whales.

Suffolk County historian Paul Bailey described the Indian dugout canoe as "Long Island's original whaleboat." To make a dugout, the Indians found an appropriately large tree and then built a small fire at the base that was kept burning until the tree could be felled. Taking the proper length of the trunk, they lopped off the branches and tapered the two ends by alternately charring the wood and scraping off the ash. They also notched the underside so it could be more easily portaged. The Indians then formed the cockpit through alternatively burning and scraping, being careful to leave strong, high sides. Remarkably buoyant when finished, such a craft could carry between five and six men. The crew propelled the vessel from a crouching position using short broad paddles. On a hunt, the Indians employed at least two such canoes and usually a small fleet of them both for reasons of safety and in order to ensure the capture of so large an animal.

It is not surprising that, given the dangers of the hunt, the Native Americans preferred to take advantage of the bounty offered by dead whales washed ashore, sick whales that practically beached themselves, the young and much less powerful calves and other such targets of opportunity. We know from the accounts of early colonists that such whales, called "drift" whales, were plentiful during the whaling season.

Beginning as early as 1640 with the arrival of the first English settlers in Southampton, the white man began to emulate the Indians' shore-based whaling techniques. The settlers knew the value of a whale; for a long time, in other corners of the globe, ocean whaling had been a lucrative profession. In the sixteenth and seventeenth centuries, the English, Dutch, Norwegians and others engaged extensively in whaling.

The settlers made a few improvements to the Indians' whale-hunting practices. Most importantly, the settlers devised a better small boat. Using native cedar planking, the colonists constructed an open cockpit craft resembling a long rowboat, only with two pointy ends instead of one. Their design made the boat light for easy portage, seaworthy and both fast and maneuverable. The English settlers also used iron points for their harpoons, another significant improvement.

Surprisingly, the industrious Dutch colonists living in New Amsterdam and at points on the western end of Long Island did not much engage in shore whaling. Historian Paul Bailey writes that it wasn't until 1652 that the West India Company, which operated and governed the province of New Netherlands, wrote to Director General Peter Stuyvesant, instructing him to open up a whale fishery because it would add a great deal of profitable commerce.

In 1655, Peter Stuyvesant dispatched a delegation to eastern Long Island to investigate the whaling activities there. Stuyvesant was annoyed to learn that the mostly English Eastenders had been busy shipping a great deal of whale oil directly to Boston, bypassing New Amsterdam completely, and that lucrative shore whaling was being done as far west as today's Nassau County. Adding insult to injury was that the English settlers were harvesting all the whales, with Indian assistance, with no Dutch participation. But before Stuyvesant and the West India Company could initiate any significant Dutch whaling activity, a larger problem arose. In the late summer of 1664, New Amsterdam fell to the surprise incursion of four British frigates and became New York.

Whaling by the white man on the beaches of what we know today as Fire Island began in 1653 when an enterprising gentleman named Isaac Stratford built the first whaling station there. He selected a location a little more than two miles west of Smith Point, close to Old Inlet. At the time, Old Inlet was probably an actual deep-water channel running all the way to the mouth of today's Carman's River. Such a waterway made it relatively easy to ferry men and material back and forth to the beach and the barrels of whale oil from the beach to the mainland. Stratford called his station and try works (the facility used for boiling blubber into oil) Whalehouse Point. Bearing the same name today, Whalehouse Point is just west of Molasses Point and Quanch Island in the Fire Island National Seashore Wilderness Area across the Great South Bay from Bellport.

From November through late March, Stratford's men, the majority of them Indians, lived at Whalehouse Point in primitive beach huts, watching

constantly from makeshift towers for the spouting of a passing whale. With the call from a tower of "Whale off!" the men would grab their harpoons and quickly launch their boats into the churning surf.

Historians say that, by the late 1600s, the whole of the South Shore was lined with whaling stations. Whaling had become a very important industry for everyone. Lion Gardiner, lord of the manor at Gardiner's Island, looked out for drift whales. William "Tangier" Smith, the owner of the forty-thousand-acre St. George's Manor in Brookhaven, including all of Fire Island, kept a watch station on his beach at Smith's Point. And following his death in 1705, his wife, Martha Tunstall Smith, took over supervision of their just-off-shore whaling business. In 1707, Mrs. Smith's personally maintained accounts showed that their operation had brought in twenty whales.

In those early days, whaling was primarily cold, boring work, with people standing endless hours as a lookout on the top of a tower searching the watery horizon for the telltale white spray from a blowhole. While the job was not for the intellectually curious or for the thin of blood, it also brought occasional brief periods of pure adrenaline-pumping excitement. Pursuing a monster of the sea from tiny wooden boats with hand-thrown harpoons in the wintertime Atlantic could be literally death defying and, often enough, death causing. But the money made it worthwhile.

With the British takeover of New York, British officialdom quickly became interested in profiting from the prospering whaling business. According to *Discovering the Past: Writings of Jeanette Edwards Rattray, 1893–1974*, East Hampton historian Jeanette Edwards Rattray wrote that, in 1665 when New York became a province under the special dominion of the Duke of York, Colonel Richard Nicolls, the first governor of New York, called a convention and presented the sixteen towns of Long Island with a set of new laws, called the "Duke's Laws." Among other things, the Duke's Laws stated that "any whale or such like great fish cast upon the shore of any precinct, shall be taken into the care of any of the officers...until the Governor and Council shall give further order therein. And, the acknowledgement which shall be received for whales—cast upon the shore of any precinct shall be the fifteenth gallon of oil." Much to the colonists' displeasure, American whales had become "royal fishes."

But levying a tax on royal fishes and collecting it are two different things. The colonists generally ignored Governor Nicolls's tax. According to historian N.R. Howell, writing in the September 1941 issue of the *Long Island Forum*, in 1686 the governor of the province of New York, Thomas

Dongan, decided that the crown was not enjoying sufficient benefit from the South Shore's whale harvest. Thus he levied a duty of one-sixth of one gallon of every gallon of whale oil produced. And, as something of a control mechanism, he tried to force all those engaged in whaling to obtain a license. But the independent-minded coastal residents ignored him, too, even skirting the armed vessels Dongan had sent to patrol the Long Island Sound in an effort to stop them from shipping their oil tax free via New England.

In 1699, the Earl of Bellomont arrived in New York as governor with orders to clean things up. He wrote back to London that he found the east of Long Island a "rendezvous and sanctuary for pirates," blaming much of the trouble on William "Tangier" Smith. In return, the Eastenders mounted a campaign to discredit the earl. By 1711, with the whale men still not paying up, the then governor of New York, General Robert Hunter, ordered that all whale oil was subject to a 5 percent tax and that a license was mandatory.

In *Discovering the Past,* Rattray points out that it was not tea but whale oil that caused the first deep divide between the American colonists and their British rulers. A century before the Boston Tea Party, the people of eastern Long Island were complaining bitterly about British taxation without American representation.

One of the original leaders of the South Shore whaling industry and a representative to New York's General Assembly was Captain Samuel Mulford of East Hampton. Mulford led his constituents in fighting the governor's dictates, even traveling to London on two occasions to petition the British government directly to remove its onerous whale oil taxes. He made his first visit to London in 1704 and the second in 1716.

In 1716, Mulford managed to sway the British government to look favorably on his cause. A story goes that a primary reason for Mulford's success was all the positive media coverage he received during his visits. The media coverage derived not from his profession or his mission but from his invention of an antipickpocket methodology. Tired of having his wallet lifted by pickpockets (to this day a favorite criminal pastime in London), Mulford sewed fishhooks into his vest and pants pockets, managing to literally snare several thieves. Reportedly the British public loved his invention and him for his courage, Yankee ingenuity and common sense. In 1720, London lifted the whale oil taxes, making Captain Samuel Mulford a South Shore and East End hero.

By the early 1700s, the number of whales swimming close to shore had begun to diminish. However, the demand for oil from these ocean-cruising oil

wells had gone in the opposite direction, and so the pursuit of the leviathans moved from the sands of the Great Barrier Beach to the more dangerous environment of the open ocean.

The tough whalers from the beaches went to sea, first for days at a time and then for periods of up to a month, mostly in small open sailboats, braving the worst of the Atlantic winter weather. But competition from New England coastal ports was building. While the settlers in the towns of New England had not done much shore whaling, by 1670 the harbors in Nantucket and New Bedford had begun sending out larger boats to hunt and capture whales off shore. Long Island's Eastenders, not wanting to lose out, moved north to Sag Harbor, from where their bigger ships might put to sea.

By 1730, Sag Harbor had become the third largest whaling port in the country. By the late 1700s and early 1800s, the larger sailing ships from Sag Harbor, Nantucket and New Bedford took over as the primary vehicles for pursuing whales. Jeanette Edwards Rattray wrote in her book *"Whale Off!" The Story of American Shore Whaling* that, by the 1850s, whaling's heyday, Nantucket, New Bedford, New London and Sag Harbor served as the great ports for American whale ships. Out of about 900 whaling vessels worldwide, 770 flew the American flag.

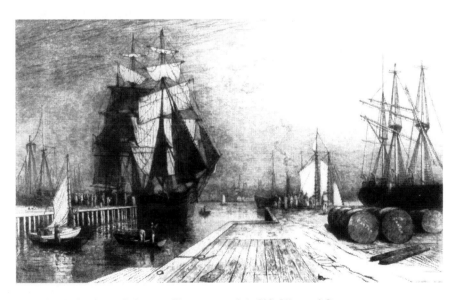

A whaler drying her sails in port. *Photo courtesy of the U.S. Library of Congress.*

Not only did whaling become and remain one of young America's preeminent industries, employing thousands and making fortunes for many, it also served as a backdrop for the introduction of great American literature. While Herman Melville, with his novel *Moby-Dick; or, The Whale*, first published in 1851, is recognized as the American author most famous for a story of New England whaling, James Fennimore Cooper was also much taken with the dangers and romantic adventure of whaling.

Beginning in 1819, Cooper traveled to Sag Harbor from his home in Scarsdale staying at Fordham's Tavern, located where the railroad station is today. Historian N.R. Howell writes that Cooper organized in Sag Harbor the first of what became known as company ships (i.e., a whaling ship owned by a number of parties). Cooper owned the controlling interest in the whaling ship *Union*, which made a total of three voyages only one of which proved financially successful. It was also in 1819, at the age of thirty, that Cooper wrote his very first novel, *Precaution*, on a dare from his wife. Much of the story was reportedly written in Sag Harbor. Also, his novel *The Sea Lions or The Lost Sealers*, published in 1849, describes a whaling expedition and real East Hampton characters in the story.

Jeanette Rattray reports a Long Island church entry of March 1846 that conveys a vivid image of the dangers of whaling, an image made world famous only a few years later by Herman Melville. She writes, "'Rensselaer Conkling and Charles Isaacs—killed by a whale last summer.' Nine months later, the news had just reached these men's families at home on Long Island; Rensselaer Conkling was the 'Uncle Rance' of whom tales are still told in Amagansett; when his shipmates last saw him he was bound out to sea on the back of a raging whale."

While Melville's story is said to be based on the story of the whale ship *Essex* and her sinking by an angry sperm whale, the image of Captain Ahab fastened to Moby Dick might well have come from the story of "Uncle Rance."

American whaling began to wane with the advent of the Civil War. Whaling out of Nantucket ceased in the late 1860s, and the last whaling voyage from New Bedford was in 1925. The last right whale caught off the South Shore was taken off East Hampton in 1918.

Chapter 5

WEST SAYVILLE'S WIDOW MOLLY INN

The history of pirate activity in and around the waters of Fire Island and the Great South Bay is replete with numerous colorful accounts. While over the years many, if not most, of the stories have been embellished in the retelling, almost all are based on actual historical events. For example, it is a fact that gold and silver treasure were buried in the dunes, that evil men and women lured dozens of ships into grounding on the bar, and that loves were won and lost in the pursuit of illicit gain. One story—the original event dating from circa 1775—captures all the elements of a classic Great South Bay–Fire Island pirate adventure.

This is the story of "Widow Molly," originally told as a single chapter in a book entitled *The Pot of Gold: A Story of Fire Island Beach* by Edward Richard Shaw (1855–1903), published in 1888.

Widow Molly was a strong and independent colonial-era woman who was the owner and hostess of a small inn situated "Westward of Greene's brook on the road to Oakdale" near the Great South Bay. Shaw describes her as quite attractive with "broad hips of which she was a trifle proud, a round arm and a good sized foot, a full bosom but no sag, and her weight must have been not more than a pound or two either side of one hundred and sixty." Other descriptive phrases portray Widow Molly as someone even the average pirate might think twice about attacking. She was a sturdy lass with black curls escaping from under a mobcap, her rolled-up sleeves revealing arms not unused to stirring the stew pot, hauling firewood and clearing the garden.

Shaw tells the reader that Widow Molly, together with her slave, Ebo (New York State did not abolish slavery until 1827), and her maid, Judy, hosted

travelers even before the Revolutionary War (1775–1783). One, a "dashing young squire of wealth" from the area of "Ronkonkoma Pond" enjoyed visiting the inn when on duck hunting trips with his treasured flintlock rifle. (Note: Flintlock muskets, also called "firelocks" at the time, were the high-tech weapons of the day. The musket was a muzzle-loaded smoothbore long gun that could be loaded with a round lead ball or with shot when going bird hunting. The effective range was usually between forty and one hundred yards. Weapons specifically designed for hunting birds, perhaps the case with the squire, were called "fowlers" and usually of large caliber.) Shaw describes how the squire trusted Molly so much that he allowed her to keep and clean his prized weapon.

As the story goes, one spring day pirates sailed their schooner through Fire Island Inlet and anchored off Great River. It was the pirates' usual practice to enter the bay at Fire Island Inlet and, sailing with the prevailing southwest wind, attack any ship in sight until reaching St. George's Manor (Bellport Bay). From there they exited into the Atlantic through a deep-water passage known as Smith's Inlet. Today this passage no longer exists. In the 1830s, two ships sank in the channel, causing sand carried by the currents, tides and the occasional severe storm to collect and seal off the inlet completely. The Smith's Inlet location now bears the name Old Inlet.

From their anchorage off Great River the pirates launched a small craft, making straight for the old limekiln landing just south of Widow Molly's Inn. The old limekiln would have stood in the immediate vicinity of today's Blue Point Oyster Company buildings and the West Sayville marina. The early settlers used such rudimentary furnaces to produce quicklime by burning oyster shells; the product was then used for mortar, plaster and in agriculture.

On this occasion, the local populace was lucky and saw the pirates coming. A half-dozen armed men positioned themselves at the old limekiln, and when the pirates were within range, they opened fire, forcing the pirates to flee. But about six weeks later, the pirates returned. This time they left their schooner anchored in the ocean, apparently somewhere near today's Fire Island Pines. They then sailed their small boat to the beach, portaged the boat over the dunes to the bay side and made straight for the old limekiln and the Widow Molly's Inn.

This time, using their small boat, the pirates were able to approach the old limekiln completely unnoticed by the locals. Reaching shore, they quickly

covered on foot the few hundred yards to the inn, barging straight through the front door. The pirates forced Ebo and Widow Molly to serve them, as they ate and drank everything in sight. The outlaws then ransacked the inn, leaving nothing of value. One of the worst pirates of the lot (the only figure Shaw identifies by full name) was Nate Crosby. It was Crosby who managed to find the widow's secret gold stash hidden beneath the rafters in the attic—a find said to be worth £180.

Despite the devastating surprise attack, Widow Molly remained strong. When one of the pirates seized upon the squire's prized flintlock, she sprang at him in a great fury, snatching it from his grasp. When a second pirate tried to take it, he met the same fate as the first. But a third pirate was cleverer than the first two and stole the weapon when the widow was distracted. The pirates then fled across the bay to their mother ship. Heartbroken, Molly was upset not with the loss of so much gold but with the fact that the squire's gun had been stolen.

Soon the entire South Shore was aware of the attack. Within several days, twenty-six armed men from Blue Point, Patchogue, Islip and Bay Shore gathered at the old Blue Point Tavern to decide what to do. (During the Revolutionary War period, today's small South Shore village of Blue Point served as a significant port.)

Meanwhile, as luck would have it, before the pirates could get underway, a severe storm blew up, causing their schooner to broach in the surf and ground on the beach. With their ship out of commission, the pirates were left high and dry on the Fire Island beach somewhere near today's Point O'Woods.

Back in Blue Point, planning their pursuit of the pirates, the armed men selected "Captain Ben from Bay Shore" to be their leader. Captain Ben met with Widow Molly, who petitioned him to do whatever he had to do—not to recover her gold but the prized gun belonging to the squire. That very night Captain Ben led his men across the Bay to Long Cove at the eastern end of Fire Island. From there they walked west down the beach toward Point O' Woods and the beached pirate vessel.

At first light, the men surprised the pirates and, in fierce hand-to-hand combat, captured every one of the rapacious brigands. The pirates were handcuffed and turned over to the law, thereby ending, at least for a while, the Great South Bay's scourge of the skull and crossbones. Captain Ben recovered none of the gold, but he did recover the squire's flintlock, which he promptly returned to Widow Molly.

Hearing the story of how Molly had saved his prized weapon, the squire is said to have thanked the widow with more than a single passionate kiss and, as the story goes, made her his happy bride.

Today the story is legend. However, news accounts from long ago indicate that Shaw's story may not be too far from recounting actual events. The historian Benjamin Franklin Thompson, in his 1839 book entitled *History of Long Island*, cites a news story that seems at least close to the events of Shaw's legend. Thompson cites the following as appearing in the *New York Gazette* of June 4, 1781:

> *A number of whaleboats got into the South Bay, near Islip from Connecticut, and took off one vessel and plundered some others. They also robbed several people on shore. This induced a royal party of militia to follow the crews of the boats down to Canoe Place (across from Smith's Inlet), where they surprised them, killed one, wounded another, and made the whole party prisoners, with four boats and thirty stand of arms; a part of the pirates were subsequently confined in a sugar-house in New York.*

While Shaw did not say his story of Widow Molly was based on the story appearing in the *New York Gazette*, it seems entirely possible. There is also the brief story that appears in Chapter 11 of the 1935 Clarissa Edwards study, *A History of Early Sayville*, entitled "Aunt Polly's Gold Coins." It, too, may have contributed to Shaw's work. This story says:

> *On a clear calm morning a small boat came through the inlet and crossed the bay to our shore. This news traveled quickly and it was not long before the cry, "The British! The British!" reached Aunt Polly at the Green Inn. She thought immediately of her gold coins. Where could she hide them? Under each bedpost on the floor she placed a precious piece of gold.*
>
> *The soldiers came to the inn and demanded food and drink. They roamed about, searching the cellar, attic, and barn. When at last they departed Aunt Polly hurried upstairs. Alas! The coins were gone.*
>
> *This story was told by Isaac Henry Green to his children, Ralph and Lila, descendents of Willett Green. The inn stood on the main road just east of Rollstone Avenue.*

The photo, probably taken circa 1890, is believed to show the house pictured below after renovation either by Israel Corse, Commodore Bourne or possibly both. *Photo courtesy of the Sayville Historical Society.*

Pictured is what is believed to be the house built on the site of the "Widow Molly Inn," or Green Inn, probably utilizing timbers from the original inn. *Photo courtesy of the Sayville Historical Society.*

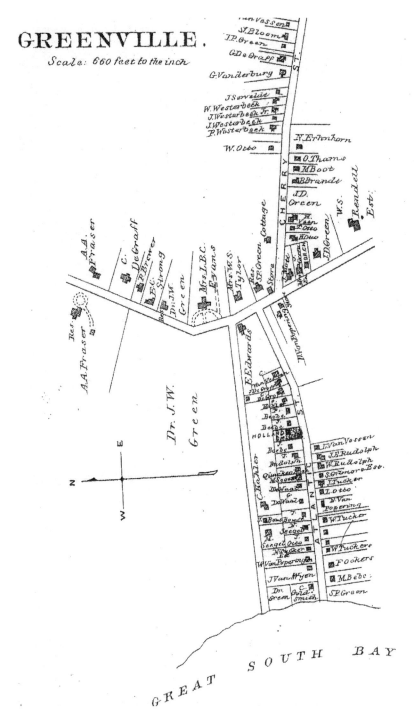

The 1888 map of Greenville with the apparent "Widow Molly Inn" or house showing the owner as Mrs. L.B.C. Evans. *Courtesy of the Sayville Historical Society.*

Edwards identifies Willett Green as "the son of John Green, born in 1757, (who) built his home upon land purchased from the Nicoll Land grant, situated east from Green's Creek."

Also lending credence to a real Widow Molly's Inn, or Green's Inn, is a story that appeared in the *Suffolk County News* of March 28, 1913. The issue carries an undated reprint from the *Brooklyn Eagle* that reports that the multimillionaire owner of Indian Neck Hall (now St. John's University and formerly LaSalle Military Academy), Commodore Frederick Gilbert Bourne (1851–March 9, 1919), was planning on razing a local structure of historical importance. The *Suffolk County News/Brooklyn Eagle* article states the following:

> *The famous old house at West Sayville, known as the "Widow Molly Inn," which at various times during its existence has been the Country Seat of many prominent families, is about to be torn down. Cdr. Frederick G. Bourne, the present owner, has offered it for sale to anyone who will tear it down and cart it away. It is a landmark of note, and many are loath to see it go, even in the grand march of progress that is sweeping the vicinity of the Bourne Estate.*
>
> *All of the history hovering about the old house is not known, but during more recent years it has been the home of such well known people as Charles A. Frost, Israel Corse, the Marberrys, and even the Bourne family occupied it when they first bought their Oakdale tract, which has been largely and magnificently added to since.*

(The May 19, 1911 issue of the *Suffolk County News* identifies the location of the inn as "the old Bourne house on the north side of Main Street opposite West Ave.")

> *It was the girlhood home of Edith Corse Evans, who so heroically gave up her seat in one of the lifeboats of the* Titanic *to a mother and two children and went down herself with the ill-fated steamer.*
>
> *It is one of those quaint, old-fashioned dwellings of several gables and projecting upper windows, huge chimneys, and immense fireplaces. The interior is quaint and holds its atmosphere of colonial days notwithstanding the fact that it has been remodeled several times.*

(*Suffolk County News* articles mention the house being renovated by Israel Corse in 1881–82. Probably Commodore Bourne also had work done when he bought the house following the death of Israel Corse in the summer of 1885.)

> *The land on which the house (inn) stands is a part of the Nicoll patent, a grant from the Crown long before the revolution. While it is said to have been built in pre-revolutionary days, its exact lines of occupancy cannot be traced. Some of the older natives of West Sayville have in the past regarded it with awe, as it was said to have been haunted by the ghosts of dead, sea pirates who had at one time plundered it. But in later years viewing its occupancy by so many persons, they have given up this idea in belief of the legend which is so beautifully told of the "Widow Molly" by the late Richard Edward Shaw, who published some years ago a book on "Legends of Fire Island Beach and the South Side."*

Finally, the *Suffolk County News* of Saturday, August 18, 1888, on page 3 under a column entitled Important Sales of Real Estate, carries the following information on a real Widow Molly Inn. It says:

> *The people of Sayville will be especially interested in Mr. Edward Shaw's new book. "The Pot of Gold, A Story of Fire Island Beach," just published by Bedford, Clarke & Co., New York as one chapter of the book, named "Widow Molly" relates what for the main part, actually happened in this neighborhood about a century ago. The "residence" mentioned in the following paragraph which opens the chapter is none other than the Corse place, and the lot with cedars on, is the one directly across the road.*
>
> *Westward of Greene's brook on the road to Oakdale there stands a substantial country residence. You will recognize it in driving by, for just south, across the road is a lot with small spindle cedars growing all irregular, everywhere in fact, some perhaps the height of a man's waist, but the most not higher than his knee. "Poor land" you will say. Well, I believe it is. Else why are those little wizened cedars there? They have grown there who knows how long?—They never get bigger and have each the appearance, when you come close, of being a hundred years old. But the lot with them on, bends its mile of curve gradually down to the Great South Bay, and leaves you a broad view of that body of water, very blue and very beautiful at times. A century and nine years ago, there stood across the road opposite*

this lot a small inn. At what time it was demolished, I could never learn: but I have no doubt some of its wrecked timbers are doing upright duty to this very day, in bracing the partitions of the present residence.

What a shame the old Widow Molly/Aunt Polly, Frost, Corse, Marberry and finally Bourne house was demolished and the timbers carted off! Today we would designate the house a National Historic Landmark. It would be a historic treasure, a reminder of our local pirate past and a wonderful monument to the memories of the courageous women who lived there. Today a modern residential apartment complex known as Dutchman's Cove occupies the site of the Widow Molly Inn. Perhaps the complex might more appropriately have been named Heroine's Harbor in honor of Edith Corse Evans, Widow Molly, Aunt Polly and probably several more heroic women whose names remain anonymous.

THE FIRST PURPLE HEART

The Purple Heart is the medal awarded to Americans who have been wounded or killed in combat. Many do not realize that General George Washington created—and awarded—the first Purple Heart. On May 3, 1783, Washington presented the first Purple Heart to a Continental army sergeant in great part for the sergeant's valiant service on November 23, 1780, in a battle on the eastern coast of the Great South Bay. How did this remarkable event come about so close to the beaches of Fire Island?

The story begins not long after the August 1776 Battle of Long Island and the subsequent occupation of the entire island by the British army. At that time, a deepwater channel existed from the mouth of Carman's River to the Atlantic Ocean through Fire Island at today's Old Inlet. For the British army, this easy access for deep draft vessels from eastern Long Island to the Atlantic Ocean was of strategic importance. Control of the channel and the inlet had to be insured. To do that, the British decided they needed a fort.

In the fall of 1780, on a small bluff overlooking Bellport Bay near Smith Point in Mastic, the British built Fort St. George. The fort's heavy canons controlled the river, the eastern bay and the channel through Fire Island into the Atlantic. The fort also functioned as a receiving and distribution center for British army troops and as a depot for providing the British forces with timber, fodder for their animals and food for the troops. The American military leadership decided they had to destroy the fort and thus devised a bold plan.

At 4:00 p.m. on November 21, 1780, Major Benjamin Tallmadge, General Washington's twenty-six-year-old spy chief, deployed two companies of dismounted dragoons, eighty men in all, from Fairfield, Connecticut, in a total of eight whaleboats. They rowed across the British-held sound, arriving

at Old Man's (near today's Mount Sinai Harbor) at about 10:00 p.m., where they immediately began a march south across Long Island. But by 11:00 p.m., a heavy rain forced Tallmadge to return his troops to the concealed whaleboats. The contingent remained at Old Man's all night and through the next day until about 7:00 p.m., when the soldiers again began their march south. At 3:00 a.m. on November 23, they stopped to rest, approximately two miles from the British fort.

Just before 4:00 a.m., Tallmadge's men divided into three groups and moved quietly through the forest toward the fort. Tallmadge thought the element of surprise to be so important that he ordered his men not to load their weapons but to rely only on their bayonets.

But even in the near total darkness, the fort's lone sentry managed to detect the shapes of the approaching armed men. He shouted out, "Who comes there?" Receiving no reply, he fired his single shot weapon at the closest figure, missing his mark. No sooner had the smoke cleared the sentry's gun than Sergeant Elijah Churchill, leading one of the three attack units, sprang into action. Sprinting toward the sentry, Churchill didn't break stride as he drove his long steel bayonet cleanly through the sentry's chest.

With that, Tallmadge and the others abandoned any pretense of stealth and charged the fort, yelling at the top of their lungs, "Washington and glory!" They quickly captured the main fort with no additional loss of life on either side. But then, with the Patriot troops celebrating, shots rang out from the windows of two houses that were a part of the fort complex. Tallmadge's troops returned fire and attacked the houses.

The battle for the houses was brief but intense with vicious hand-to-hand combat. Only ten minutes after it had started, Tallmadge's troops gained control and the fighting ended. A number of British soldiers and Loyalists, including women, were seriously wounded. A half-dozen British troops lay dead, having been shot or run through and then, while immobilized, thrown out second-story windows. The Patriot troops suffered only one minor injury.

After burning two British supply vessels anchored in Bellport Bay, Tallmadge and his men returned to Old Man's with their fifty-four British prisoners in tow. On the way, they also destroyed a three-hundred-ton supply of forage held by the British in Coram. By nightfall, the entire Patriot party had reboarded their whaleboats, arriving back in Fairfield by 11:00 p.m. on November 23. They had completed an amazingly successful commando raid deep into enemy-held territory without losing a single man.

In a formal letter, General George Washington congratulated Tallmadge and his men for their outstanding service. But it was twenty-six-year-old Sergeant Churchill's remarkable actions in killing the sentry and leading the charge on the fort that helped convince Washington he needed some special award for individual valor in battle.

On August 7, 1782, in announcing the creation of a medal he called the Badge of Military Merit, General Washington wrote, "Whenever any singularly meritorious action is performed, the author of it shall be permitted to wear on his facings, over his left breast, the figure of a heart in purple cloth, edged with a narrow lace of binding. Not only instances of unusual gallantry, but also of extraordinary fidelity and essential service in any way shall meet with due reward."

Washington's choice of the color purple has perplexed historians since his announcement. There is no known testimony or evidence to indicate why he chose a color that, at the time, was considered odd for a badge signifying military merit. It also seemed ironic to many that the general had chosen the shape of a heart to symbolize a man's unusual gallantry on the field of battle.

It would not be until May 3, 1783, at the Continental army's Newburgh, New York headquarters that General Washington would award Sergeant Elijah Churchill of the Fourth Troop of the Second Continental Dragoons America's first Purple Heart. The general cited Churchill's performance at Fort St. George and also his later effort in the October 1781 raid on the British Fort Slongo, near today's Northport. At Fort Slongo, the British quickly surrendered but not before Sergeant Churchill, who again led the charge, was wounded—the only American casualty.

As far as is known, General Washington awarded the medal to only two other soldiers, Sergeant Daniel Brown and Sergeant Daniel Bissel, both from Connecticut. But Sergeant Churchill's badge is the only one of the three original badges awarded by Washington that has survived. It was preserved by his family and is now on display at the New Windsor Cantonment State Historic Site near Newburgh.

From the first Purple Heart awards in the early 1780s, we have to fast forward almost 150 years to the early 1930s before the medal reappears. When General Douglas MacArthur took over as chief of staff of the army, he wanted a medal that could be given to military personnel in combat situations. Realizing the 200th anniversary of the birth of George Washington

was close at hand (Washington was born at Pope's Creek Plantation in Westmoreland County, Virginia, on February 22, 1732), MacArthur ordered work on a new design for Washington's Badge of Military Merit. The job of redesigning the new version of the medal went to Miss Elizabeth Will, a U.S. Army heraldic specialist in the Office of the Quartermaster General.

Then, with the design complete and the draft of the implementing General Orders in hand, MacArthur crossed out "Badge of Military Merit" and wrote in "Purple Heart" instead. Thus on February 22, 1932, under the signature of President Herbert Hoover, MacArthur issued War Department General Order No. 3, which said, in part, that the Purple Heart, established by General George Washington at Newburgh, New York, on August 7, 1782, was hereby revived out of respect to his memory and military achievements.

Today the Purple Heart is awarded in the name of the president of the United States to any member of the U.S. Armed Forces who, while serving after April 5, 1917 (the award was made retroactive), has been wounded or killed. A wound for which the award is made must have required treatment by a medical officer.

No one knows for certain the total number of Purple Heart recipients, but it is in the millions. The most Purple Hearts received by one individual is an almost unbelievable eight. Even more remarkable is that six U.S. Army soldiers share that distinction. One of these, Richard J. Buck, won four Purple Hearts in the Korean War and four in the war in Vietnam. Robert L. Howard received eight Purple Hearts in Vietnam as well as the nation's highest military award, the Medal of Honor.

Who are some of the more notable people who have received the Purple Heart? Actor Charles Bronson and writer Kurt Vonnegut are two celebrity recipients. But for most Americans, a Purple Heart has a more personal story—an award received by someone who is known but to them and their immediate family.

Chapter 7

THE TRUTH ABOUT FIRE ISLAND PIRATE JEREMIAH SMITH

It was probably in the late 1700s that Islip's Jeremiah Smith began to become the man the world would eventually know as Fire Island's most notorious land pirate. However, recently discovered documentary evidence from long ago suggests that the infamous pirate is most likely a composite of characters, a legend built up by writers and storytellers over the years based on the real Jeremiah Smith.

As with many residents of the Islip area in the late 1700s, Mr. Jeremiah Smith ventured to the Fire Island Inlet area as often as he could to catch fish and shoot fowl for himself and his large family. He also probably served as a guide/host for those willing to pay for the privilege of enjoying the unsurpassed hunting and fishing. And as with many South Shore fishermen, he quickly learned how treacherous the sand bars off Fire Island's ocean beaches could be, particularly in bad weather and especially for the big sailing ships traveling into and out of the port of New York. Early on Smith would have become well aware of the considerable profits to be made from salvaging the goods of ill-fated vessels. Ship and cargo owners of the day frequently complained, often bitterly, that the people inhabiting the South Shore of Long Island possessed a unique sense of ownership, allowing them to believe anything that came ashore from a wrecked vessel was theirs to keep.

The newly discovered information about Jeremiah Smith came to light in documents examined at the Suffolk County Historical Society in Riverhead, New York. From the archives, noted society archivist Ned Smith produced a manuscript dating from approximately 1875 written by the then prominent Long Island lawyer, Samuel Arden Smith (1804–1884). The work is a lengthy piece on the famous Smith family of central Long Island. Included

are several pages of testimony from Mr. Edward S. Mulford of Patchogue, New York, the grandson of Fire Island's Jeremiah Smith.

Mulford wrote that on September 15, 1773, his grandfather, Jeremiah Smith, was born into the family of Long Island farmer Zebulon Smith. Working as a farmhand and helping to provide for the Smith family as a hunter and fisherman, Jeremiah Smith grew to manhood laboring long hours in and around the sparsely populated areas of Dix Hills and Clay Pits in Huntington. Smith lived his formative years during the difficult, seven-year-long British occupation of Long Island (1776–1783), an experience that may have had some impact on his attitude toward the law and law enforcement authorities later in life.

Mulford wrote that not long after the turn of the century, following work as a club housekeeper in Islip, "Uncle Jerry" as he was known, "went to Fire Island opposite and south of east Island [*sic*] (to work) as a Public House Keeper."

If we assume that Mulford's "east Island" is actually East Fire Island, then Jeremiah Smith's work as a public house keeper would have been on the main beach a couple of miles east of where the first Fire Island Lighthouse was constructed in 1825. However, there exists no known record of any structure functioning as a public house or inn anywhere close to the Fire Island Inlet before 1825. Yet it is probable that enterprising South Shore citizens engaged in seasonal businesses, catering to the visiting hunters and fishermen of the day. Good money might be made from guiding hunting and fishing parties made up of wealthy Yorkers (a Long Island slang term of the time for wealthy gentlemen visitors from New York), including the rental of equipment and perhaps even space in informal beach structures or huts where food and drink might be served.

As Harry Havemeyer points out in his book *Fire Island's Surf Hotel*, it was not until Felix Dominy's tenure as Fire Island Lighthouse keeper from 1835 to 1844 that Fire Island Inlet had anything resembling what we might think of as an inn. Dominy and his wife, Phoebe, began their business by taking in guests for the night in the lighthouse keeper's quarters. By 1844, Dominy was out of his job as lighthouse keeper—there had been a number of complaints that he spent too much time at questionable tasks completely unrelated to keeping the light. That same year, Felix became the proprietor of the prosperous Dominy House, his wood-frame establishment located about a mile east of the lighthouse on the western end of today's Kismet community.

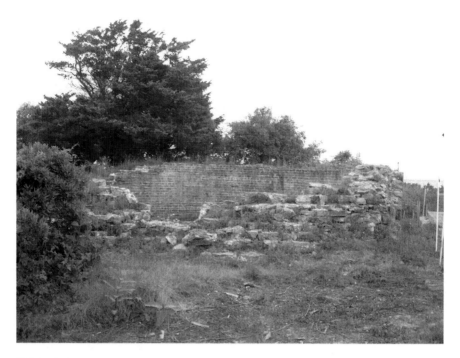

This is all that remains of the first Fire Island Lighthouse erected in 1825 and replaced in 1858. *Photo courtesy of Elaine Kiesling Whitehouse.*

Thus, without hint of any structure on Fire Island even resembling an inn until circa 1835, it would seem that Edward Mulford's assertion that Uncle Jerry went to Fire Island as public house keeper is a misstatement, but perhaps not. Mulford may well have been referring to the kind of work Smith was doing and not to any specific position at an established business. In other words, Uncle Jerry probably spent at least some of his time working the tourist trade as a hunting and fishing guide and as a host at primitive, self-constructed beach shacks where he served food and drink to his hunting and fishing parties.

The Mulford text indicates that Uncle Jerry, probably sometime after the birth of his thirteenth child on February 11, 1821, left his wife and children behind in Islip while he went to live more or less full time at the beach. There he was free to concentrate on building up a service business as a public house keeper and, more profitably, to harvest the rich bounty from dead and dying ships.

But even if Smith were particularly aggressive and adept at recovering lost cargo, he was not alone in his thievery. As we know, many South Shore

residents of the day spent a lot of time at the beach collecting and profiting from shipwrecked cargo. So what accounts for Smith's singularly notorious reputation for piratical infamy? At least part of the answer may be that Jeremiah Smith simply received more publicity than anyone else. The following will explain how that came to be.

Mr. William Post Hawes (1803–1842), a high profile New Yorker, was an accomplished lawyer, a colonel in the New York State militia and an avid sportsman who loved hunting and fishing. In addition, Hawes indulged a "secret" passion for writing. He loved to write exciting travel stories based on his hunting and fishing adventures. To avoid potential embarrassment and possible conflict of interest with his work as a prominent lawyer and military officer, Hawes wrote his adventure stories under the pen name J. Cypress Jr. His stories, published in *American Monthly Magazine*, the *Mirror*, the *New York Standard* and eventually the *New York Times*, were well received by the reading public.

Following Hawes's death in 1842, his longtime friend, Mr. Frank Forester, edited a book called *Sporting Scenes and Sundry Sketches: Being the Miscellaneous Writings of J. Cypress, Jr.* Forester's book, in two volumes, presented a collection of Hawes's previously published writings. The successful Forester book provided even wider distribution to the earlier published Hawes (J. Cypress Jr.) stories.

The stories reprinted in volume 1 of Forester's book are primarily based on Hawes's early nineteenth-century hunting and fishing trips to Fire Island Inlet and the Fire Islands (two small islands near the Fire Island Inlet). One lengthy piece is entitled "Fire Island-Ana; or a Week at the Fire Islands"; another, identified as a legend, is called "The Wrecker of Raccoon Beach" (an early name for today's Fire Island) "or, the daughter of the Sea." Jeremiah Smith is the central character in both pieces. In the first, he is seen as keeper of the light at the Fire Island Inlet. In the second, he is the infamous land pirate of Raccoon Beach who is married to a beautiful mermaid with two unusual and remarkably aquatic children. Reading these stories makes it clear that they serve as the basis for the Jeremiah Smith pirate stories and legends that have lived on to this day.

In the "Fire Island-Ana" story, Hawes writes:

> *Upon our arrival here (at the beach), we put in alongside of the new wharf of the eximious Mr. Smith, a person of no little importance, being a man under authority, having a wife over him, a keeper of their majesties',*

the people's, lighthouse, adjoining his own tenement, duly appointed and commissioned, a lawful voter, a licensed vendor of "spurrets and things accorden," and the only householder upon the ridge.

Now as far as is known, no one named Jeremiah Smith ever served as keeper, or even assistant keeper, of the Fire Island Lighthouse. A man by the last name of Isaacs was keeper from 1827 until 1835, the year Felix Dominy took over. When Dominy left in 1844, a man by the name of Eliphalet Smith became the keeper serving until 1849. It is unclear when Mr. William Post Hawes visited the lighthouse; however, we know it was sometime between 1826 and 1842 because Mr. Hawes passed away in 1842. Thus, the keeper at the time of the Hawse visit(s) would have been either Mr. Isaacs or Mr. Dominy and not Jeremiah Smith.

One remote possibility is that Uncle Jerry preceded Mr. Isaacs's tenure, serving as keeper—officially or unofficially—between the end of the lighthouse construction in 1826 and when Isaacs took over in 1827. But the Fire Island Lighthouse Preservation Society records show no keeper from 1826 to when Isaacs took over. It is conceivable that if Hawes visited the lighthouse between 1826 and 1827, Uncle Jerry might have been serving as keeper. But again, no record exists within the society's records of Jeremiah Smith ever being a keeper. It also seems illogical that a man with a dozen or so children would accept such full time work so far away, cut off in bad weather, from his young family.

So where then did Hawes come up with Jerry Smith as keeper at the Fire Island Lighthouse? The answer appears to lie with poetic license and Hawes's style of writing. While Hawes wrote entertainingly and managed to accurately capture the essence of the rugged life on the beach and the rough-hewn nature of the people who lived and worked there, he appears to have allowed himself the luxury of composite characters and camouflaged names. In other words, Jeremiah Smith was a real person at the beach but not the lighthouse keeper. Felix Dominy, who seems to have shared a number of the legendary Uncle Jerry's talents and personality traits, may have been the actual lighthouse keeper about whom Hawes wrote. But Hawes, always the lawyer, did not want to describe Dominy in any sort of defamatory way and so identified the Dominy persona as Jeremiah Smith. Another example of Hawes using camouflage for the real characters in his stories is the fact that in "The Fire Island-Ana" story, Hawes uses his pen name and persona, not his true identity, as a participant in the adventure.

Another beach character Hawes introduces to his readers is identified as Raynor Rock, a man described as living in a beach hut and catering to sporting clients. Is this character the real Jeremiah Smith? Probably so, but Raynor Rock almost certainly derives at least some of his character from the real Mr. Raynor Rock Smith of Freeport, Long Island.

Raynor Rock Smith was a hardy soul who spent his days watching over Jones Inlet for ships and people in trouble. On a frigid January 2, 1837, Raynor Rock Smith performed a feat of heroism that would bring him national recognition. On that day, a barque went aground on the outer bar in a fierce winter storm. She carried a crew of 12 with 112 passengers, almost all Irish immigrant women and children. Seeing the disaster unfold from his place on Long Island, Raynor Rock Smith sprang into action. He and three of his sons dragged a small wooden boat over the frozen bay to the beach, portaged the boat to the ocean side and eventually reached the *Mexico*, which was stranded about three hundred yards from shore. In a raging storm, the four managed to rescue the ship's captain, his son, five passengers and a sailor before being forced to stop by the horrible conditions.

Days later, other rescuers finally managed to reach the stranded ship, but they found no survivors. They discovered entire families frozen together in a final ice-entombed embrace. They found one man seemingly frozen in time, his head bowed and his hands clasped in prayer. Recovery crews found a total of only 77 of the 116 who perished.

Raynor Rock Smith performed in such a magnificently heroic fashion that a committee of prominent New Yorkers was formed to present him with an award for his humanitarian service. Thus, on March 25, 1837, the committee met Raynor Rock Smith at Oliver Conklin's hotel in Hempstead. The leader of the presentation committee was none other than Mr. William Hawes, whom we now realize was also the author J. Cypress Jr.

In "The Fire Island-Ana" story, Hawes tells his readers the following about his character Raynor Rock—again, probably the real life Jeremiah Smith:

Raynor Rock's fishing-hut was about two hundred yards from our landing place, and an equal distance from Jerry's [again, "Jerry" in the Hawes story probably being the real Felix Dominy] *the domicile and the light-house. After securing our boat, we unloaded her, and carried our oars, and guns, and traps, to Jerry's, and took lodgings. This was for form sake merely, knowing, as we did, that the most of our time would be spent in*

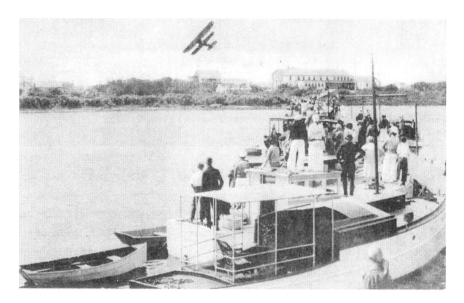

The Cherry Grove dock with the hotel and a biplane in the background. The year was 1929. *Photo courtesy of Judy Stein and Ken Stein.*

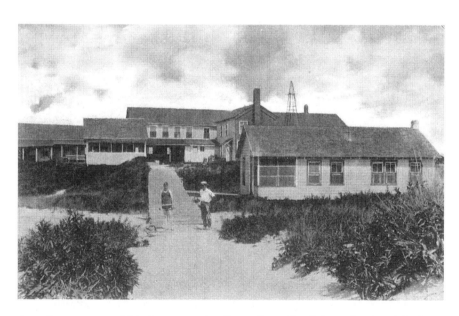

According to many published accounts, the Cherry Grove Hotel sits on the site originally settled by Jeremiah Smith. *Photo courtesy of Judy Stein and Ken Stein.*

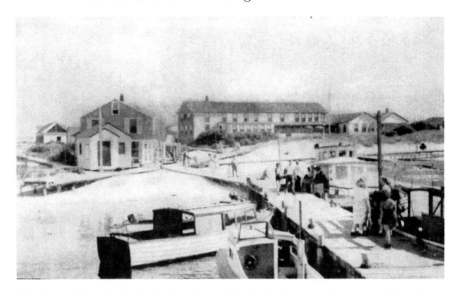

The Cherry Grove dock. The little white building in the foreground is the post office. *Photo courtesy of Judy Stein and Ken Stein.*

the bay, or in Raynor's hut. Jerry was not in a very amiable mood when we arrived, and we had none of us, any especial [sic] commendation to tarry long, except, perhaps, Oliver, who came rather reluctantly out of the kitchen, where we found him, as usual, helping the help. However, we soon got away, and started for Raynor's, bearing the always easy burden of a jug of special stuff, which we knew would not come amiss of a rainy night. A hop, a skip, and a jump, a few times repeated, brought us to the welcome which has already been recorded.

The Edward S. Mulford account also tells us that Mulford's grandfather, Uncle Jerry Smith, eventually left his house on the beach and returned to Patchogue, Long Island, where he died on August 8, 1860, an old man approaching his eighty-seventh birthday.

It seems the truth about Uncle Jeremiah Smith is that he enjoyed a good and full life with most of his days spent hunting, fishing and salvaging on and off the beaches of Fire Island. And thanks to the literary efforts of Mr. William Post Hawes, his friend, Mr. Frank Forester, and others who followed them, the pirate Jeremiah Smith left behind a legacy still entertaining to us all.

Chapter 8

THE MYSTERY AT OLD INLET

Early in the evening of Friday November 5, 1813, eleven men from Fire Place and the village of Brookhaven on eastern Long Island decided to take advantage of the calm, clear and warm weather and go fishing in the Atlantic just off Fire Island's Smith's Inlet (today's Old Inlet). Most of the men probably had sailed in and out of the deepwater passage on numerous occasions and in weather and sea conditions that would test the skills of even the best of small boat sailors. But within hours of setting sail, all eleven men were dead, their boat destroyed. To this day, no one knows how or why a sturdy fishing boat and its entire crew of healthy and experienced men, in fair weather—perhaps no more than one hundred yards off the great barrier beach—could all be lost.

Provided below is a description of the facts of the case as known, what local officials, family members and historians have theorized over the past two hundred years and several new details suggesting what may have actually occurred.

On November 17, 1813, a New York City newspaper, the *Columbian*, republished a *Long Island Star* news account of the tragic Old Inlet incident. It reads as follows:

> "*Melancholy Occurrence*"
>
> *Rarely, indeed, has it been our painful duty to record a more melancholy occurrence, than one which recently took place in that part of Brookhaven called Fire-Place.*
>
> *In the evening of Friday, the 5th Instant, eleven men, belonging to that village, went to the south shore with a seine, for fishing; viz. William Rose, Isaac Woodruff, Lewis Parshall, Benjamin Brown, Nehemiah Hand, James*

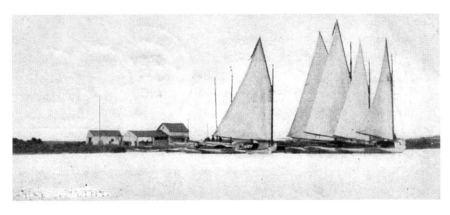

Old Inlet as it looked circa 1906 showing the near total absence of any dunes behind the houses. *Photo courtesy of Judy Stein and Ken Stein.*

Homan, Charles Ellison, James Prior, Daniel Parshall, Henry Homan and John Hulse. On Saturday morning the afflicting discovery was made that they were all drowned. It is supposed that the whole party embarked in one boat, and went to the outer bar—a distance of two miles from the shore, and which at low water is in some places bare; but that by some accident the boat was stove or sunk, and the whole party left to perish by the rising of the tide, which at high water is 8 or 10 feet on the bar. The boat came on shore in pieces, and also eight of the bodies. The six first named have left families. Long will a whole neighborhood lament this overwhelming affliction, and the tears of the widow and orphan flow for their husband, father and friend.

On May 7, 2010, the archivist for the County of Suffolk pulled from her files in Riverhead the coroner's inquest reports for each of the eleven men who perished that night. In 1813, much the same as today, the Suffolk County coroners held an inquest whenever the cause of death was sudden, suspicious or in some way other than from natural causes.

A review of each of the reports shows that the coroner provided only the briefest review of the circumstances and possible cause for each individual's death. Using a single side of one sheet of paper, the coroner simply stated that on November 5, 1813, the individual concerned went to sea to go fishing and accidentally suffocated and drowned.

A check of other inquest reports prepared by the same two Suffolk coroners (their names were Ebenezer Hart and John Elderkin) who did the reports of the November 5 incident reveals that those done for the Old Inlet Eleven were

unusually abbreviated. Other inquest reports by the same two coroners, including deaths from drowning at sea, include much more detail on the circumstances leading to the individual's death; for example, the weather, condition of the boat, time of death, etc. It would appear the Old Inlet coroner's reports were done simply to satisfy a bureaucratic paperwork requirement and nothing else.

The newspaper account cited above tells us that eight of the eleven bodies washed ashore, but the coroner's reports provide no evidence to indicate this was the case; in fact, it would appear that the coroners and/or witnesses actually saw only three of the eleven bodies. If that were so—as it would appear to be—then we do not know for certain what the cause of death was for eight of the eleven men. Was it drowning or something else?

On October 5, 1933, Mr. Osborn Shaw of Bellport's Fireplace Literary Club provided the following information in a letter read by him at the Brookhaven Library:

> *Of the terrible calamity that befell this community, there is not an old family in this section but knows about it. On Friday night, the 5th of November 1813, eleven men from this vicinity went as a fishing crew over to the South Beach. Just what happened will never be definitely known, but from what was printed in the* Long Island Star *of 10 Nov. 1813 and from what my late grandmother and father and the late Capt. Chas. E. Hulse have related to me, the men went through "Old Inlet" and hauled their boat on the "dry shoal" in the ocean opposite the inlet. The shoal was bare at low water but covered at high tide. While busily engaged in shaking out their net, they did not notice that the tide was rising under their boat and it being not properly secured, it floated away in the swift current running through the inlet. When they realized their predicament, they began calling for help, and set up such a howling that their cries were heard over here in Fire Place, it being a calm moon-light night.*
>
> *One woman here, went to a neighbor's and remarked that something must be wrong over on the beach, as she was sure she recognized her husband's voice. It is told that another rival crew was at the time, also on the Beach, and that they were fiddling and drinking and some of their members were drunk. Some one of them heard the cries of the imperiled men and suggested going to their aid. He was greeted with the remark: "Damn 'em, let 'em drown" from another member and the eleven men were left on "dry shoal" with the tide gradually rising over them.*

Every man was drowned and there were six or seven women left as widows here the next morning. The names of the men were William Rose, Isaac Woodruff, Lewis Parshall, Benjamin Brown, Nehemiah Hand, James Homan, Charles Ellison, James Prior, Daniel Parshall, Henry Homan and John Hulse. The boat came on shore in pieces and eight of the bodies were recovered.

I have located the tombstones of some of them. William Rose was buried on the ground on which this building stands, but was removed some few years ago to the present village cemetery; Isaac Woodruff's stone is in St. John's Cemetery in Oakdale; the two Parshall boys have a stone in the old Patchogue Cemetery on Waverly Avenue; Benjamin Brown's body and stone were removed to the Bellport Cemetery; Nehemiah Hand's stone is in the Presbyterian Cemetery in South Haven. If the other five have stones, I have failed in finding them.

One clue as to what really happened that night appears to have been overlooked in its importance, and that is the condition of the boat following the incident. The November 1813 news account and the Osborn Shaw account both say "the boat came on shore in pieces." If the seas were calm and the boat had been carried away on the tide, as explained, then the boat should have come back ashore in one piece or at least in good shape and not "in pieces," as described. Also, the news account even says, "by some accident the boat was stove or sunk," implying significant damage to the boat from some outside force.

Another oddity is the contention that eleven experienced men would leave their fishing boat beached and completely unattended on a sandbar at night on a fast moving tide. It hardly seems logical that all eleven men would leave their boat on a November night to work their nets on a flooding sandbar.

Another hint at what may actually have happened is the missing bodies. The evidence indicates that at least three and perhaps as many as eight bodies were either not recovered at all or not recovered prior to the preparation of the coroner's reports. Once again, if the seas were calm and the tide incoming, then more of the bodies should have been recovered.

The news account also errs in describing the bar outside Old Inlet as being two miles from the shore. It probably lay no farther than a couple of hundred yards off shore, if that far. Today, the charts of the sea floor off Old Inlet reflect no trace of any bar whatsoever.

If the men were in the neighborhood of two hundred yards from shore, the seas were calm, the water at that time of year still reasonably warm and

the tide incoming, would it not have been possible for at least one or two of the men to make it safely to shore, and if not, why not?

Another apparent inaccuracy in the reporting is the claim that "their cries (for help) were heard over here in Fire Place." It is a near impossibility for anyone floating or standing two hundred yards or more out in the Atlantic Ocean off Old Inlet to be heard by someone else in Fire Place, a straight-line distance of more than four miles interrupted by breakers, dunes, waves and shorelines. Also, it seems highly unlikely that the men mentioned as drinking on the beach would disregard cries for help from their neighbors in trouble at sea. It seems far more probable that, after the fact, someone on the beach may have said they might have heard cries for help but did not see anything they could, or needed, to do.

So what explanation is left for what actually happened? If we assemble all the known pieces of the puzzle and add to the mix the benefit of almost two hundred years of Fire Island history, what may well have happened that night begins to reveal itself more clearly. Consider the following scenario:

We know the boat and her men disappeared in the evening. As any fisherman can tell you, the evening is a time when nature's creatures feed most actively and aggressively. Also, the change to an incoming tide would have increased the odds of big fish actively seeking their prey.

The men may have beached their boat on the exposed outer bar, and some of them may well have gotten out to tend their nets or to go for a swim or, for whatever reason, went splashing around near the boat. A man splashing in the ocean water is said to look a lot like a seal, an animal we now know to be a favorite food of certain large ocean predators.

History tells us seals had been plentiful on Fire Island for centuries, so much so that the local Secatogue tribe called the barrier beach Seal Island. Fire Island waters were a favorite hunting ground for predators bent on devouring seal meat. Furthermore, the drop off between shallow and deep water—in this case between the outer bar and the deep—is recognized by any fisherman as a good place to catch big fish. Today we know what they did not know in 1813. The largest predatory fish in the world still swim in Fire Island's coastal waters and can be extremely deadly and destructive.

Part of the reason great white sharks are so destructive is that they ambush their target from below. They have been clocked at well over twenty-five miles per hour, sometimes moving even faster, launching themselves toward the target above them, going so fast they actually breach out of the water.

Today some of these predators reach a length of well over twenty feet and can weigh as much as five thousand pounds, as big and as heavy as a pickup truck. There may have been even larger specimens in 1813, long before it became popular to hunt them. From the movies and TV, we can all visualize what a predator this size can do to a forty-foot wooden sailboat. For the small Fire Place sloop, such an ambush attack from so powerful a predator would have been devastating.

What may well have happened is the men from Fire Place did indeed go fishing just outside Old Inlet, they did set their nets, some of them may well have gotten into the water and, following an attack, they may have cried out for a time in fear and agony. But in short order, they lost any chance to survive, even in the still warm waters not far from shore.

As the great white came at one or more of them from the deep, it was already too late for all of them. The creature killed one or more of the men in the water and smashed the wooden boat into pieces, knocking those onboard into the sea. Some may have stayed with parts of the boat for a time, others may have drowned almost immediately and some may have been taken whole, or nearly so, by the awesome predator. No one could make it to shore alive. All the men succumbed to shock, trauma and worse.

The people of the day who reported on the incident probably had little or no knowledge of a predator like the great white and the horrific damage such a creature can inflict. Without eyewitness accounts, it makes sense that no one of the day would choose to speculate on the existence of a giant ocean predator as the cause of the loss of eleven men and their boat. Even if some suspected an attack by a giant predator, they knew wives, mothers, family members and friends could far more easily accept drowning as a cause of death than the nightmare of a loved one chewed to death by a monster.

Then again, perhaps it was a very large creature of a different kind. Today we have numerous accounts of whales striking ships of all sizes, almost always by accident. In 1813, from late fall into early spring, the waters just off Fire Island were still a busy pathway for migrating right whales. Could the demise of the little fishing boat have been the result of a collision with a whale?

Of course, there is no way to prove what actually happened, but an attack by a large great white or even a right whale fills in many of the missing pieces in this still mysterious incident. We may only hope that perhaps someday new facts will come to light to tell us exactly what caused the loss of those eleven men on such a tragic night out upon the sea.

Chapter 9

THE SUMPWAMS
CREEK INCIDENT

While the Revolutionary War, the Civil War and the more modern conflicts of the twentieth and twenty-first centuries command most of our collective remembrances of war, the approximately three-year-long War of 1812 also brought us great heroes and remarkable events that live in the American consciousness. For example, because of the War of 1812, we have "The Star-Spangled Banner." We also live with the history of a foreign enemy burning down the White House and the image of Dolly Madison literally running out the back door, clutching national treasures as the British approached. In song and literature, we celebrate General Andrew Jackson and his magnificent triumph at the Battle of New Orleans, a victory undiminished by the fact that it came after the official end of the war. There is much to remember about the heroic figures and events of America's second and much less-celebrated conflict with the British Empire.

During the War of 1812, the Fire Island Inlet had constantly shifting sand bars, no navigational aids, no channel markers and no fixed geographical reference points; the first lighthouse would not be built until 1825. For a boat crew unfamiliar with the narrow strait, sailing through it in anything other than perfect weather conditions could be highly problematic. In the War of 1812, this difficult body of water played an interesting if not all-but-forgotten role in a significant event involving the famous American naval hero, U.S. Navy captain David Porter. The thirty-two-year-old Porter had become an American naval hero early in the war because, as the British navy said of him, he was fearless in battle, he never shied away from a fight and he was always willing to take on vessels much larger and better armed than his own.

The U.S. Capitol after its burning by the British. *Photo courtesy of the Library of Congress.*

By way of background, and for those working to recall why the United States fought the War of 1812, a quick reminder. In brief, America fought out of a desire for economic independence. In the decades following the Revolutionary War, the British continued to control Canada, retain American territory along the Great Lakes, encourage and support hostility by the Native American tribes on the U.S. frontiers and interfere in U.S. foreign trade. Also, pressed by the exigencies of the Napoleonic wars (1799–1815), the British navy claimed the right to take from American merchant ships any British citizens serving on them. The British navy's frequent practice of kidnapping American sailors along with British seamen—a practice known as "impressment"—became too much for the American public to bear.

In 1807, in an attempt to solve the British kidnapping problem, President Thomas Jefferson told Congress to enact an embargo banning *American* (my emphasis) merchantmen from foreign trade, thus to starve the British of American goods and force a change in British policies. The idea failed miserably, accomplishing little more than ruining the American shipping industry. So, by the elections of 1810, most Americans had had enough of British harassment and American retreat and thus elected to Congress many who advocated war, a group of men collectively known as the "War Hawks."

By 1811, many Americans came to see the liberation of their poor Canadian cousins from oppressive British colonialism as their patriotic duty. Many also viewed the Canadian people as requiring American rescue from the fearsome Indian tribes inhabiting their land. And, from perhaps a uniquely American point of view, many saw the Canadians as being in need of American investment and business acumen to enable exploitation of the rich natural resources Canada had in abundance.

The War Hawks argued that American forces could quickly defeat the British, the citizens of the invaded Canadian territories would welcome Americans with open arms, Americans could acquire lucrative properties and contracts without difficulty and the effort would cost the federal government next to nothing because it would all be over so quickly.

In June 1812, the U.S. House of Representatives voted 79–49 and the Senate 19–13 in favor of President James Madison declaring war on the British Empire. Thus, on June 18, 1812, Madison did precisely that.

In the War of 1812, much of the military action took place at sea, with American frigates and privateers taking on ships of the British fleet wherever they could. What is not well known is that one of the most intriguing and ironic chapters of Porter's story took place in early July 1814 in the Fire Island Inlet and the small seashore town of Babylon, Long Island. Here the heroic Captain Porter found himself in a dire situation right on his own doorstep. How did he get out of it?

Porter became an almost instant sensation when, at the start of the War of 1812, he sailed from New York Harbor as commanding officer of the frigate USS *Essex* and immediately met with success in battle. The 140-foot long *Essex*, carrying forty-six guns, and with a complement of three hundred officers and men, quickly captured a number of British merchantmen and a British troop transport bound for Canada. Then, in early August, the *Essex* engaged the British gunship *Alert* and, after a brief battle, emerged victorious. Porter and his *Essex* had managed the first defeat of a British man-of-war in the conflict, thereby giving a tremendous morale boost to all Americans.

Captain David Porter sailed the *Essex* south, eventually approaching the equator. There, in mid-December 1812, he enjoyed significant success in capturing the British ship *Norton* carrying about $50,000 in gold bullion. The U.S. government needed money, and this represented a considerable contribution to government coffers.

Continuing south, by early 1813 Porter had decided to take his ship around Cape Horn and into the Pacific where he could attack British whalers and paralyze the lucrative British whaling industry. By mid-June 1813, Porter had a small fleet of captured British vessels at his command, including one he renamed *Essex Jr.*

The British admiralty, tired of Porter's attacks, in late September 1813 dispatched the thirty-six-gun frigate *Phoebe* and two escorts under the able command of Captain William Hilyar to the South Pacific to hunt down and destroy the troublesome *Essex*.

By early January 1814, the *Phoebe* had found Porter and his *Essex*, with the *Essex Jr.* in company, anchored in the neutral port of Valpariso, Chile. For a variety of reasons, Porter and Hilyar did not immediately engage. Porter, essentially trapped in the harbor, decided to wait out his enemy.

But Porter grew restless and on March 28, 1814, when storm-strength winds came up, snapping one of the *Essex*'s mooring cables and causing one anchor to drag, Porter decided to make a run for it. But things did not go according to plan. The fierce gale tore off the ship's topmast, leaving her incapacitated in the rough seas, unable to provide a credible defense against the two approaching British warships.

Hilyar kept his ships out of the range of *Essex*'s guns while continually pounding the American with his long guns. Trying desperately to catch up and engage the bigger, faster ship, for hours *Essex* took a terrible long-range beating. Bloody dead and wounded piled up everywhere, fires broke out, and there was no escape. By six thirty in the evening, the furious fight was over; Porter was finally forced to lower his colors. Of the officers on board, only Porter and Lieutenant Stephen Decatur MacKnight remained uninjured. Porter's adopted son—also a future U.S. Navy hero, Midshipman David Farragut—was among the wounded.

Captain Hilyar, unable to keep Porter and his surviving crewmen prisoner, issued them a parole. The British removed all the guns from *Essex Jr.*, placed Porter and his unarmed men aboard the converted whaler, and finally, on April 27, sent them on their way back to New York.

Following a long and dispiriting sail, Porter and his remaining crew aboard *Essex Jr.* finally arrived off Sandy Hook on July 6, 1814. There they were stopped by the fifty-six-gun British man-of-war, *Saturn*.

The British captain, a man named Nash, seemed of two minds with regard to his apprehension of the well-known Captain David Porter, his crew

and the *Essex Jr.* Initially Nash received Porter and his men with courtesy but then, apparently following advice from underlings, demanded all of the Americans' documentation. Nash then abruptly declared Captain Hilyar's parole no longer valid and the ship and her crew his prisoners.

Porter became incensed, making a show of offering his sword to Nash, signifying that he now thought of himself as once again a prisoner of war. Nash refused to accept Porter's sword but ordered Porter, his ship and crew to be detained alongside *Saturn*. Porter immediately became determined to escape.

Early on the morning of July 7, under cover of the fog-shrouded darkness, Porter and nine other men slipped over the side into a whaleboat and made good their getaway. Porter famously left behind a note addressed to the vexing Captain Nash. The acerbic note asserted that most British officers are not only destitute of honor but also mindless of the honor of each other. The note said that Nash should know that he (Porter) was armed and was prepared to defend himself against Nash's boats if they were sent in pursuit. Nash should also know that if he (Porter) must be met again, then he should be met as an enemy.

Nash's men set out in pursuit of Porter almost as soon as Porter had gotten away from the side of the *Essex Jr.*, but the wily American captain and his men had gotten just enough of a head start. The Americans resorted to frequent course changes and other deceptions, making it difficult for the British to follow them, especially in the fog. Finally assured they had avoided their pursuers, the next challenge became how to get safely into port.

Porter and his men rowed and sailed their boat an estimated sixty to seventy miles from a location off Sandy Hook to a point near Fire Island Inlet. Porter had good reasons for proceeding in a northeasterly direction instead of due north, a course that would have put his boat ashore much more quickly and closer to their homeport of New York City. The wind and seas in this part of the Atlantic at this time of year are usually from the southwest, making rowing and sailing in a northeasterly direction considerably faster and easier than any other course. Such a course also would have most quickly put the greatest distance between them and their pursuers. The crew of the *Saturn* might have expected them to head on a course that would take them most quickly to land—either due west or due north—and so would be most likely to look for them along those routes.

Porter and his men were aware of the desolate nature of the barrier beaches off the South Shore of Long Island and the dangers of navigating

the inlets with their shifting sand bars and strong currents. According to at least one report, Porter and his men found and stopped a local sailor by the name of James Montfort and got Montfort to agree to pilot them through the inlet, across the Great South Bay to Great Cove and into port at Sumpwams Creek. In 1814, Sumpwams Creek was a lightly settled area on the South Shore of Long Island. (Today Sumpwams Creek is the natural boundary between the village of Babylon and the hamlet of West Islip. According to Richard Harmond's writing in the *Long Island Historical Journal*, Babylon's original name was Sumpwams, then it became Huntington South, in the early 1800s New Babylon and finally just Babylon.)

But Porter and his men were not yet safe. From well before the Revolutionary War, the villagers of the South Shore of Long Island had gotten used to keeping one eye open for the approach from the inlet of pirates, privateers, British raiders or other purveyors of serious trouble. Therefore, in towns and villages along the shoreline, whenever someone spotted the approach of a suspicious vessel, he or she knew to spread the word quickly, and men with arms would come running. So when the good people at Sumpwams Creek saw their friend, James Montfort, coming in through the inlet accompanied by a group of unknown armed men, they expected and prepared for the worst. Porter probably could see from a considerable distance that he would be met at the dock by an armed and apparently determined group of citizens. And so he was.

As soon as his whaleboat pulled alongside the dock, the leader of the informal Sumpwams Creek militia, a man named Stephen B. Nichols, bravely stepped forward and accused Porter and his men of being British raiders disguised as American sailors. The situation had quickly become extremely tense.

Despite this latest obstacle coming from his own countrymen and so close to home, Porter, being a wise and patient leader, decided to avert an incident everyone would regret. Instead of turning on Nichols, Porter made a grand show of giving up. Quickly and loudly, he announced his surrender, humbly offering Nichols the grip of his sword.

Undoubtedly much relieved at this turn of events, Nichols and his brave neighbors relaxed their trigger fingers. History records that within moments of handing over his sword, Porter produced papers identifying himself, beyond a doubt, as the famous U.S. Navy captain of the USS *Essex*. The villagers now became not only relieved but also ecstatic. A real live national

hero had escaped from the British to their little village! From that moment, Stephen Nichols, James Montfort and the other residents of the South Shore village could not have been more welcoming.

Soon a farm wagon was brought down to the dock, and Porter's whaleboat was removed from the water and hoisted atop the wagon. The nine crewmembers clamored aboard and, with the local residents cheering and pulling the boat and trailer, began the joyous trek to the Brooklyn Navy Yard. Following not far behind came Captain Porter in the village's finest carriage, reportedly pulled by the best horse available.

Eventually arriving at the Brooklyn Navy Yard, Porter and his men continued to receive a hero's welcome. Captain Nash, who initially had held *Essex Jr.* and her crew off Sandy Hook, had released the ship not long after Porter's escape. *Essex Jr.* had then made her way straight for New York harbor. Porter enjoyed a well-earned reunion with his men almost as soon as he reached New York City. There he also reunited with his adopted son, David Farragut, at only thirteen years of age, already a wounded veteran.

Thus it was that the Fire Island Inlet, with its long history of pirates and raiders entering the Great South Bay through it, almost cost the country the life of one of its most important naval heroes.

Chapter 10

THE MEMORY OF
MARGARET FULLER

Born in Massachusetts more than two hundred years ago, Sarah Margaret Fuller (May 23, 1810–July 19, 1850) remains as pertinent and inspiring an American story as any modern-day biography. Hers is the fascinating tale of an independent and keenly intelligent woman working all her life to achieve remarkable breakthroughs in a world dominated by competent and aggressive men. Margaret Fuller relied on her superior intellect to win friendships with powerful people and advance the humanitarian causes she championed. She also endured enemies such as Edgar Allan Poe, who said humanity could be divided into three classes: men, women and Margaret Fuller. What is most remarkable is that a woman so far ahead of her time, and of such great intellectual accomplishment, has had so little public recognition given to her memory. A small plaque once mounted on a boulder at the ocean's edge in Point O'Woods on Fire Island, long ago washed out to sea, has been the only physical memorial to this outstanding woman.

In her forty-year life span—a lifetime cut tragically short by her drowning in a shipwreck off today's Point O' Woods—she managed to leave behind a legacy unmatched by any American woman up to that time. A brilliant orator, educator, author, editor and literary critic, she was the first woman permitted to use the Harvard College library, the first female journalist in America and the first female foreign correspondent. Feminists such as Susan B. Anthony and Elizabeth Cady Stanton, writing in 1881 in their *History of Woman Suffrage*, described Margaret Fuller as possessing "more influence on the thought of American women than any woman previous to her time." In 1852, James Freeman Clarke in her biography wrote, "Margaret's life had

Margaret Fuller. *Photo courtesy of the Library of Congress.*

an aim, and she was, therefore essentially a moral person, and not merely an overflowing genius. It was a high, noble one, wholly religious, almost Christian. It gave dignity to her whole career, and made it heroic."

In 1816, at the age of only six, Margaret Fuller could translate from Latin the works of Virgil and Ovid. By twelve, she could quote from Shakespeare and Plato and intelligently debate points from John Locke's metaphysics. She also learned Italian and German, and in her teenage years, she became so competent in the German language that she was considered an expert on Johann Wolfgang von Goethe, one of the preeminent writers and thinkers in our Western culture.

Not long after losing her father and educational mentor to cholera in 1835, Fuller began a lifelong friendship with Ralph Waldo Emerson. By 1839, she had accepted the position of editor of the new Transcendentalist movement journal, the *Dial*. Contributors to the periodical included many of the great minds of the day: Emerson, Henry David Thoreau, Bronson Alcott, Elizabeth Peabody, Theodore Parker, Nathaniel Hawthorne and others. As editor, she encouraged contributions from the best of the best, critiquing their work and even rejecting material not up to her standards.

She wrote many of the *Dial*'s articles herself. Perhaps her most important work was "The Great Lawsuit," written in serial form for the *Dial*. In 1845, she expanded the work, calling it *Woman in the Nineteenth Century*. The work consisted of her voluminous knowledge of Western literature and philosophy, which she used to argue for the expanded rights of women as independent and rational beings. Not everyone loved the book. Poe commented, *"Woman in the Nineteenth*

Century is a book that few women in the country could have written, and no woman in the country would have published, with the exception of Miss Fuller."

By 1844, Fuller had come to the attention of another idealist—and future presidential candidate—Horace Greeley, then the editor of the *New York Tribune*, a paper he started in 1841. (The paper merged in 1924 with the *New York Herald* to form the *New York Herald Tribune*, which lasted until 1967.) Greeley hired her as a literary critic and columnist, in the process convincing Margaret that the *raison d'être* behind the *Tribune* was to provide the public with an intelligent and reliable alternative to the sensationalist tabloids of the day. Following Fuller's death, in 1851 Greeley's paper employed Karl Marx in the same role it had employed Margaret—as its European correspondent.

Greeley, suffragette wife Mary Cheney Greeley and Fuller took to one another almost immediately; in fact, they got on so well that Margaret lived in the Greeley house in Turtle Bay, Manhattan, in 1844–1845. In 1846, Fuller left New York, promising to provide Mr. Greeley and his newspaper with stories from London and elsewhere in Europe. Fuller traveled to Scotland and then France before stopping in Rome in 1847. There she became an admirer of the policies of the leader of the Italian Unification Movement, Giuseppe Mazzini, and became involved in the Italian Revolution. She also fell in love with one of Mazzini's primary deputies, a man ten years younger than herself, Marchese Giovanni Angelo Ossoli. Fuller became pregnant, and in September 1848, she gave birth to a son whom they named Angelino Eugene.

Margaret continued to write for the *Tribune*, describing in great detail the struggles of the Italian people for independence. But by the summer of 1849, with the rebellion suppressed, the Ossolis decided to move to the United States. In May 1850, to save money and avoid publicity, the Ossolis bought passage on the barque *Elizabeth* bound for New York City.

The voyage was a disaster from the start. After only one week at sea, the ship's captain, a man named Seth Hasty, died a miserable death from the highly contagious smallpox. Upon the captain's death, the inexperienced first mate, Mr. Bangs, assumed command. Then, about two days out from Gibraltar, Margaret's two-year-old son came down with the same illness that had killed the captain. But with Margaret's constant care, Angelino survived, and was well on the road to recovery by the time the ship was approaching the port of New York. It seemed all would turn out well for Margaret but, as

she had predicted in letters to friends before the journey began, a safe arrival simply was not to be.

On the night of July 18, as the ship was making its way toward New York and an anticipated docking the next day, the wind began to pick up. By midnight, it had reached gale force, and by 2:30 a.m. on the nineteenth, the inexperienced Mr. Bangs had lost his way. Less than one hour later, the *Elizabeth* went aground. Soon afterward, a large wave literally picked the ship up and slammed her down. This time she hit broadside against the sandbar. The force of the strike broke the ship in two, with only the forward portion of the ship remaining intact and above water.

None of the passengers or crew were lost or even injured in the grounding. So after some initial confusion, everyone aboard managed to come together on the forecastle.

In the early morning light, through the gloom of the storm, they could just make out people starting to gather on the shore. But no one there appeared to be mounting any sort of rescue of any kind. With their situation becoming more and more precarious, two of the ship's crew agreed to try to swim for shore to encourage a rescue attempt. Both men made it, but then a passenger, Mr. Horace Sumner, decided to try. He drowned shortly after entering the water, in plain view of the others.

As the morning wore on, people on the shore tried to launch a rescue boat. They also tried to get a line out to the ship with a line-throwing mortar. But all such attempts failed. The mountainously high seas and howling winds precluded any further shore-based rescue attempt.

Meanwhile, on the forecastle, Mr. Bangs convinced most of the remainder of the crew that their only hope lay in grabbing hold of a wooden plank and swimming for shore. But four of the crew and none of the surviving passengers would listen. Margaret and her husband knew their precious child would never make it.

Then, about three o'clock in the afternoon, another very large wave came along and destroyed what remained of the ship, flinging everyone into the sea. The bodies of the ship's steward and little Angelino eventually washed up on the beach, but two bodies, those of Margaret Fuller and her husband, were never found.

Hearing the news of the loss, Emerson was devastated. Together Emerson and Horace Greeley decided to send Thoreau to Fire Island in hopes of retrieving Margaret Fuller's body.

Thoreau arrived at the scene of the wreck by July 24, but there was no sign of the bodies of Margaret Fuller or Giovanni Ossoli nor could he find any trace of the manuscript on which she had been working, "History of the Roman Republic." As was the common practice of the day, people living near the wreck and others from the mainland had immediately set to stripping the ship of anything of any value including personal belongings and baggage. Thoreau discovered that much of what had been taken off the *Elizabeth* had found its way to Patchogue. So off he went to Patchogue to try to track down Fuller's manuscript or anything else belonging to her and her husband. He found nothing, and so returned to Point O'Woods. Again, he found nothing. Greatly disappointed, Thoreau returned to New England, having left instructions that Mr. Horace Greeley should be contacted in the event any further trace of Margaret Fuller or her works should be recovered.

The story of what ultimately happened to Fuller's body remains something of a mystery. The first and still most accepted version is that her body, along with that of her husband, disappeared forever into the sea. However, Daniel Tredwell's *Personal Reminiscences of Men and Things on Long Island*, published in 1912, cites an interesting story about Fuller's body being found by a Captain James Wicks who secretly buried it in an unmarked grave on Coney Island.

Tredwell says that on July 19, 1901, at Point O'Woods, overlooking the waters where Fuller drowned half a century ago, a pavilion had been built and a tablet to her memory unveiled. All of the speakers at the unveiling said that the sea had forever swallowed up her body. However, in the audience was a woman who shook her head in protest each time this statement was made. The woman was a Mrs. Julia Daggett, and she said Fuller was buried on Coney Island. Mrs. Daggett said the body washed ashore on the beach some days after her friends and family had departed Point O'Woods, leaving word that Horace Greeley would see that it received a proper burial. Mrs. Daggett's father, Captain James Wicks, placed the body on his sloop and sailed to New York City, where he located Mr. Greeley. Wicks told Greeley of his finding, but for some reason, Mr. Greeley refused to take any action in the matter. Captain Wicks then took the body to Coney Island, where he secretly buried it in order to avoid any possible trouble with the authorities.

Today Coney Island is a highly populated peninsula bordering Lower New York Bay and the Atlantic Ocean, but in 1850 it was still a barren section of Long Island's barrier beach. For someone leaving New York harbor in

the 1850s, it almost certainly was the first and most convenient location to quietly get rid of dangerous or unwanted cargo.

Tredwell adds that many old sailors of the time had heard a similar tale and that even members of the Fuller family who heard Mrs. Daggett's story believe it is true.

Whether Margaret Fuller's body was ever found or buried on Coney Island or somewhere else, it will not diminish the luster of her life. In fact, a cultivation of the mystery may help to keep her image and her amazing intellect alive.

Chapter 11

CALL HIM ISHMAEL

He died in virtual obscurity. The headline for his brief September 29, 1891 obituary read, "Death of a Once Popular Author." Yet he wrote several works now considered to be masterpieces, not just of American literature but also of all English literature. This genius, unrecognized in his lifetime, was a native New Yorker born August 1, 1819, at 6 Pearl Street in lower Manhattan. He traveled the world but spent part of the end of his adventurous life on Fire Island, where he penned what many consider his greatest work. His name? Herman Melville. The work he wrote on Fire Island? *Billy Budd*.

Melville found the Surf Hotel, opened in 1856 by David Sammis on the western tip of Fire Island, to be his perfect escape. It was there, on the lonely stretches of beautiful ocean beach, that he found his muse. Melville and his wife, Elizabeth, stayed at the Surf Hotel as early as 1885, and from the summer of 1887 until his death in 1891, he spent considerable time there. An 1887 Boston newspaper society column described his situation in one sentence, "Melville, now a man of sixty odd, and the author of some very exciting sea stories extensively read about a quarter of a century ago, is staying on Fire Island."

Today Herman Melville is a household name, but at the time of his death, he had been almost completely forgotten; his longest novel, *Moby-Dick; or, The Whale*, having met the same fate. In the latter half of the nineteenth century, most readers failed to understand the allegory in Melville's 1851 masterpiece, and thus between 1851 and 1891, it sold only about three thousand copies. But even before the book was published, one individual realized the importance of *Moby-Dick*. This man, the individual to whom Melville

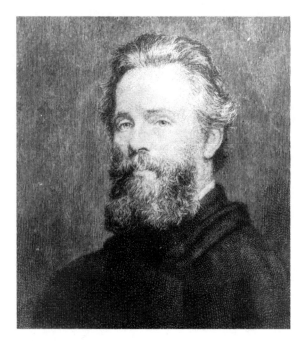

Herman Melville. *Photo courtesy of the Library of Congress.*

dedicated the now classic work, was his close friend and Massachusetts's neighbor, Nathaniel Hawthorne. Melville had all but finished his first draft of *Moby-Dick* when Hawthorne encouraged him to change it from a detailed story about whaling to the allegorical novel we know today.

"Call me Ishmael," the famous first line of chapter one of *Moby-Dick*, introduces the reader to the story's narrator, a man who feels apart from mainstream society, a man resembling Melville himself. The narrator's quest aboard the whaler *Pequod* to hunt down the mysterious white whale Moby Dick may be seen as an allegory for human striving to reach unattainable goals. Interpretations of Melville's allegory abound, but for many the seemingly unconquerable whale represents God, fate or the natural universe. The revenge-seeking Captain Ahab, in his obsessed pursuit of the unconquerable whale, suggests the pursuit of any dream when taken to extremes can destroy the pursuer. The beauty of the book is that it is open to so many different interpretations about moral and philosophical issues affecting us all.

Moby-Dick contributed significantly to an important period in American literature. In the early 1850s, Hawthorne published *The Scarlet Letter* and Harriet Beecher Stowe published *Uncle Tom's Cabin*, eventually the second bestseller in nineteenth-century America after the Bible.

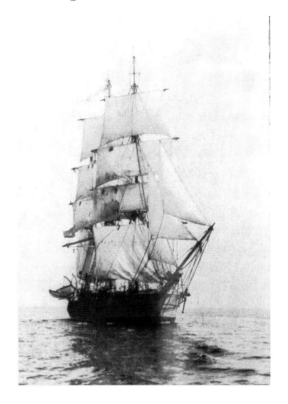

The whaler *Grayhound* underway in a light wind. *Photo courtesy of the Library of Congress.*

Melville based much of his writing on biblical stories his mother had taught him in his youth together with his personal experiences in later life. He drew on his service in the merchant marine in 1839; his days on whaling ships, particularly his eighteen months on the New Bedford whaler *Acushnet*; his brief weeks with Polynesian native "cannibals" in the Marquesas Islands; and his nearly two years of service in the U.S. Navy, from 1843 to 1844.

Eighteen months crewing on the whaler *Acushnet* taught Melville things about his fellow man that he could use in his work for the rest of his life. In cramped, uncomfortable conditions, working long months under iron-hard discipline and without distraction from the dangerous routine, he came to know the nature of men far more deeply than he might have under any other circumstances. Then he jumped ship, and cultures, in the Marquesas, where he became immersed in a society virtually untouched by Western precepts of responsibility and morality. Again, he gained a knowledge and experience few others could claim. His 1846 book *Typee* includes a description of a

remarkable love affair with a guileless and beautiful Polynesian girl, Fayaway. The popular book became his bestseller during his lifetime.

For *Moby-Dick*, some events not from Melville's experience contributed to the tale. One was the sinking of the whaler *Essex*, rammed by an angry sperm whale in the middle of the Pacific Ocean in 1820. First Mate Owen Chase, one of only eight *Essex* survivors, first wrote the story in 1821 in a book entitled *Narrative of the Most Extraordinary and Distressing Shipwreck of the Whale Ship Essex*. Before writing *Moby-Dick*, Melville read a copy purchased for him by his father-in-law. Today, Nathaniel Philbrick's bestseller, *In the Heart of the Sea: The Tragedy of the Whaleship Essex*, details the amazing story of the *Essex* and her crew.

Another event influencing Melville's epic was the reported killing in the late 1830s of an albino sperm whale off the Chilean island of Mocha. A manuscript written in 1839, which appeared in the *Knickerbocker Magazine*, described the killing of "Mocha Dick," an albino whale riddled with dozens of harpoons from previous attempts to catch him and who often attacked ships with premeditated ferocity.

By 1866, after writing a number of books that failed to excite his audience, Melville took a relatively low-paid position as a customs inspector in New York City. He needed the steady income to support his wife and four children. One year later, suicide would remove his eldest son, a stinging tragedy reflected in some of his future work.

By all accounts, Melville's wife Elizabeth (née Shaw) was a strong woman and a lifelong help to him. The daughter of the chief justice of Massachusetts, she married Melville on August 4, 1847, and bore him four children, two sons and two daughters. She stayed at his side for forty-four years despite hardships that included the eldest son's suicide, a problem-plagued second son and one daughter's severe rheumatism. She also put up with Melville's poor health that began with a breakdown in 1855, his dependency on his father-in-law for financial support and his failure to adapt his writing to a more popular style that might have brought him fame and fortune in their lifetimes.

But it was Elizabeth's health that first brought the Melvilles to Fire Island. In a letter dated July 17, 1872, Elizabeth asked a relative about staying at Fire Island as way to escape the hay fever from which she suffered each August. There is no record of the relative's reply, but the Melvilles did go to Fire Island. When Elizabeth inherited some money a few years later, they used it to spend a good deal more time at the beach and the Surf Hotel.

Melville began his last work, *Billy Budd*, at about the same time as he and Elizabeth first visited the Surf Hotel. Could it have been the muse of Fire Island, found by many on long strolls on the beach, sitting on a dune at sunset or watching the sun come up over the ocean that inspired Melville to write his last and perhaps greatest work? Thirty-five years had passed since he finished *Moby-Dick*. The only real change in his life was the chance to once again look out at the sea that had provided so much of his inspiration.

At his death in 1891, *Billy Budd* lay unfinished in his desk drawer, some of it only in notes on the borders of his manuscript. In fact, it wasn't until 1962, after exhaustive study, that the definitive edition of the book finally appeared. Even the full title of the work changed from *Billy Budd, Foretopman* to what seems to have been Melville's intended title, *Billy Budd, Sailor (An Inside Narrative)*.

The story is another allegory, using Melville's past shipboard experience to tell a tale of good and evil. Many interpret sailor Billy Budd to be Christ or a Christ-like figure, with Billy's accuser, master-at-arms John Claggart, the devil or a Satan-like creature. The ship's captain, Vere, is said to represent Pontius Pilate with unflagging commitment to his duty as captain but deeply disturbed by his human compassion for the beloved Billy. It is in Vere that we can see ourselves, conflicted to the end by our own actions.

The Surf Hotel is long gone, but the beaches of Fire Island remain almost as peaceful and pristine as they were in Melville's day. To experience a summer sunset from the Fire Island shore is enough to make anyone communicate with their muse.

Chapter 12

THE FACE IN THE RIGGING

On Friday morning, February 8, 1895, in a fierce gale and with temperatures holding near zero, the ice-encased 163-foot-long, three-masted schooner *Louis V. Place* went aground just off Cherry Grove. Soon after shuddering to a stop on the beach's outer bar, about a quarter of a mile off shore, the ship's deck came awash in the heavy seas. All eight crewmembers—including fifty-eight-year-old Captain William H. Squires—scrambled into the rigging, choosing the torture of exposure to the frigid winds over a quicker and more certain death in the waves. The only question was whether any of the eight stranded men would live to tell the tale of how the five-year-old vessel and her experienced crew arrived in such a dreadful predicament.

The potential for the loss of the entire crew did not come about for lack of rescue personnel. Despite extremely poor visibility five minutes before *Louis V. Place* went aground, U.S. lifesaving serviceman Fred Saunders, from his post on the beach, saw the ship headed for trouble. Saunders contacted the adjacent lifesaving stations for assistance and sent a messenger to his own crew, which were already busy rescuing the crew of another three-master, the *John B. Manning*. That ship had earlier gone aground about a mile east of where the *Louis V. Place* had hit bottom.

So it was not until about noon on the eighth that the rescue crews manned a Lyle gun in an attempt to set up for a breeches buoy rescue of the crew of the *Louis V. Place*, with the ice, surf, wind and rip currents making rescue by boat quite impossible. The lifesavers managed to get several lines over the ship, but because of the numbing effects of hypothermia, the stranded men did not have the dexterity to secure the lines.

Ice left in the rigging of the *Louis V. Place*. *Photo courtesy of the Long Island Maritime Museum.*

The tall masts of the *John B. Manning* and the *Louis V. Place* could easily be seen from vantage points on Long Island's South Shore, and so word of the wrecks spread quickly. The Great South Bay was frozen over, making it possible for the curious, the adventurous and many who wished to try to help in some way to trek to the scene. By the afternoon of the eighth, despite the frigid conditions, a crowd estimated to number as many as one thousand had formed on the beach. But no one could do anything to help the eight poor souls who stood freezing in plain view only a quarter mile away. No one could do anything except watch as the men suffered their slow and agonizing deaths.

At the time of the grounding, air temperatures hovered between zero and plus four degrees Fahrenheit with a continuous wind speed over fifty miles per hour, as measured at nearby facilities in Sandy Hook, New York City and Block Island. These figures placed the wind chill in the stranded ship's rigging at somewhere around minus thirty degrees. Frostbite can occur under those conditions in less than thirty minutes. Heavy snow squalls came and went. Freezing spray from the twenty-foot breakers continuously filled

the air. The sea itself, reflecting days of extremely cold temperatures, carried "porridge ice" two feet thick at the surface.

Captain Squires was the first to die. As captain, he had been the last into the rigging, having made sure everyone else was aloft. Several times the sea had seemed to wash over his position, completely drenching him. Observers noted that, being wet in such frigid conditions, Squires could not be expected to survive for very long. Within hours and without his uttering a word, Squires dropped like a stone from his station in the rigging. The crowd let out a collective gasp as the relentless seas swallowed him up, the currents carrying his lifeless body farther out to sea.

Captain William Squires received even greater accolades from those who had labored as members of his crew, as he had been respected by all who knew him for his personal integrity and skills as a seaman. It was said that he would never ask a sailor to do something he would not do himself, and he never failed to place the well-being of his crew above his own. So while the conditions of February 8 could not have been more against his survival, those

Captain William H. Squires photographed in Bridgehampton in 1893. *Photo courtesy of the Long Island Maritime Museum.*

who knew him suggested Captain Squires might have fallen as quickly as he did because of the man he was. They said he may have died as much from the extreme shock of losing his ship, and surely his crew, as from the intense cold. The remains of Captain William Squires were not recovered until several days later, washing up on the beach some thirty miles to the east, ironically not far from his Bridgehampton home. He left behind his wife, Carrie, and two beloved young children, a son and daughter. From the instant of her grounding, the huge

breakers that crashed against the hull of the dying ship had churned up clouds of icy mist that hovered around the masts and rigging. At times the windswept frozen fog shrouded the ship, giving the entire scene an aura of eeriness, almost as though the scene was not of this world. And so it was that, not long after Captain William Squires disappeared into the sea, a number of reliable witnesses on shore pointed out what they thought was the image of a desperate man's face framed in the swirling mist between the fore and mizzen masts. Not everyone could see it, but many did and later swore to it. Those who knew him said the face was unmistakably that of the man from Bridgehampton, for certain the ship's captain, Mr. William Squires.

No one can really say if it was a case of life imitating art or art imitating life, but the most remarkable thing about the image was not that people saw it, but that a photographer seemingly managed to capture it on film. Forty-eight hours after Mr. Squires left his ship for the last time, photographer Martin Anderson produced a single black and white photograph that

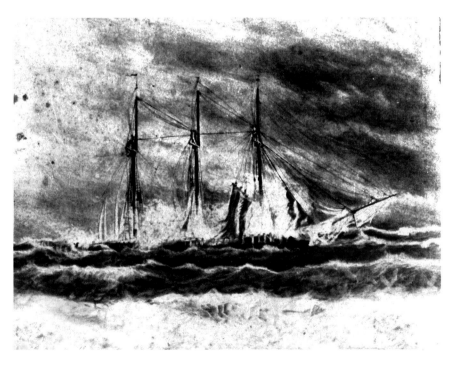

The Martin Anderson photo of the wreck of the *Louis V. Place* with the image of the ship's captain, Squires, visible just aft of the mizzenmast. *Photo courtesy of the Long Island Maritime Museum.*

captured the drama of the weather and the wreck as it had been on the afternoon of February 8. Clearly visible in the photo is the outline of a man's face framed by the mist swirling in the ship's rigging. While most consider the photograph to have been altered by Martin Anderson, the question remains whether Anderson purposely created the image to capture the story or whether the photograph is responsible for the legend.

After the loss of Captain Squires, it surprised no one to see more men begin to die. The ship's cook, Charlie Morrison, was the next to go. Charlie came from Oakland Street in Brooklyn and was a native New Yorker. A gregarious man, he liked to cook and loved to eat what he cooked. As with his captain before him, poor Charlie uttered not a sound as he fell head first from the rigging into the relentlessly pounding sea. Charlie Morrison would never be seen again, his body lost forever.

Just before dark, the crowd watched as a third crewman succumbed to the elements. The young ship's engineer from Rhode Island, Charlie Allen, appeared to literally give up the ghost, falling backward from his station on the mast, arms and legs outstretched as if in flight. His body was recovered about three weeks later just west of Moriches.

The tragedy of Charlie Allen's death was not lost on his friend and mentor, fifty-year-old Norwegian mate Lars Givby. Soon after Charlie Allen died, Lars Givby too fell from the rigging. Givby, a strong man weighing in excess of two hundred pounds, remained afloat for a brief time before disappearing under the crest of a large wave. His remains would eventually be found off Forge River.

No one else fell that Friday night, but by early Saturday morning, it was plain to see that the twenty-eight-year-old seaman August Olson was nearing the end. Olson had tried for hours to climb into the crude shelter made by Soren Nelson and Claus Stuven. The two had cut some of the lines holding the furled mizzen topsail and crept into the opening, thereby protecting themselves from the death-dealing wind. Olson was just below the crosstrees holding Nelson and Stuven, but the paralysis of his hypothermia prevented him from climbing just that little bit farther to safety. Stuven and Nelson could touch him and repeatedly reached out to try to help him but to no avail. Olson died about 2:00 a.m., frozen to the mast and the rigging just below Stuven and Nelson.

At daybreak it was plain to see that the young and handsome blond Norwegian, Fritz Ward, also had died sometime in the night. The only thing

keeping him aloft was the ice and the lashings he had used to tie himself to the rigging; he was frozen solid to the ratlines, his head rocking back and forth in the wind.

It was not until close to midnight on Saturday, more than forty hours after the ship had gone aground that the storm and violent seas abated enough to allow the lifesaving service to launch a boat. With a Herculean effort, the lifeboat crew of seven men managed to get alongside the wreck and bring Nelson and Stuven down from their refuge and safely back to shore. The two were given food and water, with Dr. George Robinson of Sayville making every effort to warm their bodies and save their lives. They were then transported for treatment to a hospital on Staten Island where Nelson, who had suffered severe frostbite, passed away only a few days later. After several weeks of recuperation, Stuven recovered his physical health and returned to the sea—the only life he ever knew. However, it was said that he was never the same man again.

As for the lifesaving crew that performed so heroically that weekend,

Crewman Claus Stuven in foul weather gear. Stuven sold a postcard similar to this photo door-to-door along the South Shore following his recovery from the accident. *Photo courtesy of the Long Island Maritime Museum.*

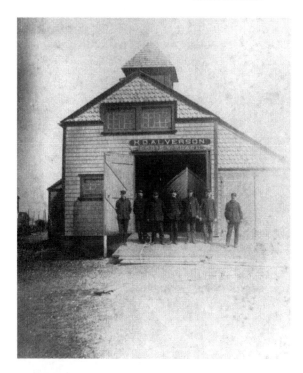

The Lone Hill Life Saving Station some time after March 1899. Above the opening for the surfboat are the quarter panels for the *Louis V. Place* and the *Homer D. Alverson*, a schooner that went aground in high winds on March 7, 1899. *Photo courtesy of the Long Island Maritime Museum.*

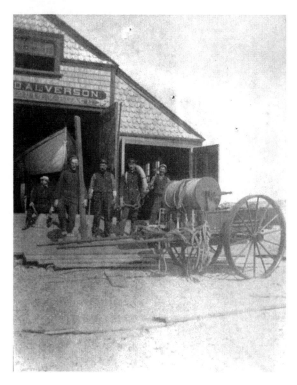

The Lone Hill Life Saving Station crew with their equipment. The Lone Hill station was across from Sayville. *Photo courtesy of the Long Island Maritime Museum.*

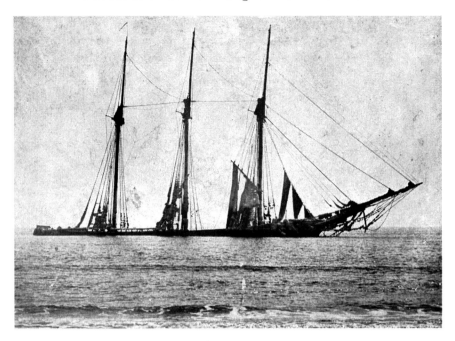

The *Louis V. Place* resting on the bottom after the storm had passed. *Photo courtesy of the Long Island Maritime Museum.*

Keeper Sim Baker suffered severe frostbite of both his hands and feet and eventually contracted pneumonia, from which he never recovered. He was not the only one to suffer; all those involved in the rescue from the lifesaving service suffered to some extent from frostbite and exposure.

Those were the kind of men who, in days gone by, dared to go down to the sea in ships, and such were the men who stood vigil on the shore to save them when they could. They are all a part of Fire Island's great heritage.

Chapter 13

FIRE ISLAND'S SPLINTER FLEET NAVY HEROES

From April 1917 to April 1919, men in wooden boats from the U.S. Navy's Reserve Fleet conducted armed patrols in the Great South Bay, Fire Island Inlet and the waters off Fire Island. Their mission was to find and engage Imperial German Navy submarines, prevent the running of supplies and information from the mainland to these same U-boats and provide assistance to other military in the area, including pilots based at the U.S. Naval Air Station in Bay Shore. Fortunately, for the approximately thirty men who went to sea on these patrols, they failed to discover a single submarine. However, the men from West Sayville's Section Base 5 contributed significantly, even heroically, to the U.S. war effort, doing so in unexpected ways.

On April 6, 1917, Congress declared war on Germany. The large and active German U-boat fleet posed an imminent threat to U.S. shipping and to the U.S. mainland. To counter the problem, the U.S. Naval Reserve established antisubmarine bases up and down the eastern seaboard. Local men, knowledgeable of their coastal waters, volunteered to man these bases. Thus, in April 1917, the docks in West Sayville became home to U.S. Naval Reserve Force (USNRF) Section Base No. 5.

The navy selected a longtime local resident, Lieutenant Robert B. Roosevelt Jr., USNRF, for command of the West Sayville naval base. Roosevelt, first cousin of the twenty-sixth president of the United States, proved an excellent choice. Well educated and an avid and experienced local mariner, he inspired confidence in the men under his leadership. To be his executive officer, or second in command, Roosevelt selected another experienced local small boat sailor, thirty-three-year-old Ensign Walter L. Suydam Jr., USNRF, of Bayport.

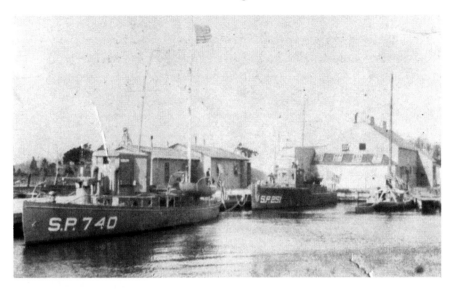

Probably taken in the late summer of 1917, the photo shows the entire "Splinter Fleet" in its homeport at the West Sayville docks. From left to right are the USS *See W. See* (SP-740), the USS *Sunbeam III* (SP-251) and the USS *Nemesis* (SP-343). *Photo courtesy of the Long Island Maritime Museum.*

The West Sayville dock as it looks today. *Photo courtesy of Elaine Kiesling Whitehouse.*

To take on the sophisticated German submarines, Section Base 5 had three wooden patrol vessels. Two of the patrol vessels were powerboats—one sixty-five feet in length and one fifty-two feet in length—but the third was a converted forty-two-foot sailboat. The sloop had a maximum speed of only about seven knots, and that was only in a good breeze when she was bailed dry.

The pride of the three-boat fleet, known with some affection as the "Splinter Fleet," was the fifty-two-foot *Sunbeam III*. Built in 1917 by the Charles L. Seabury Company and the Gas Engine and Power Company in the Bronx, *Sunbeam III* had been Lieutenant R.B. Roosevelt's private yacht. On June 16, 1917, Roosevelt officially loaned his boat to the navy under a free lease agreement for the grand sum of one dollar. With a draft of three feet, she had a respectable maximum speed of a little over twelve knots.

To make her into a warship, the navy gave the *Sunbeam III* a couple of coats of battleship gray paint, mounted a small canon (a one pounder) on her foredeck and added one .30-caliber machine gun and a signal light amidships. Commissioned on July 18, 1917, she became the USS *Sunbeam III* (SP-251). The designation SP stands for Section Patrol Craft. Most of the time, Chief Boatswain's Mate Henry Strybing commanded SP-251 with Alfred "Dutch" Ackerly as his chief engineer along with another four to six additional crewmen. Her official complement was eight.

The larger, sixty-five-foot patrol boat was also a donated and similarly converted vessel. Built in 1915 by W.F. Downs of Bay Shore, New York, she was acquired from her owner, Charles W. Cushman, by the navy on June 18, 1917. On August 18, 1917, she was commissioned the USS *See W. See* (SP-740). She, too, had a top speed of around twelve knots with a draft of three feet, eight inches.

The third boat of the Splinter Fleet was acquired in much the same way as the other two. On May 25, 1917, under another free lease agreement, the navy took possession of Ensign Suydam's sailboat, the *Nemesis*. The navy painted her dark gray and mounted a single .30-caliber machine gun on the bow, and on June 7, 1917, she officially became SP-343.

The well-known Patchogue boat builder Gil Smith had built the *Nemesis* at his yard in 1896. Officially, she was forty-one feet, nine inches in length with a beam of twelve feet, three inches, a draft of two feet, six inches and a top speed of 6.8 knots.

As far as is known, the *Nemesis* was the only U.S. Navy warship ever built in Patchogue. For the duration of the war, the *Nemesis* carried a crew of five. A

senior reservist from Patchogue named Marion Perkinson, who had an intimate knowledge of the Great South Bay, skippered her a majority of the time.

None of the Splinter Fleet carried depth charges or any other sort of antisubmarine armament. They had no communications equipment except flashing light, which, of course, was of minimal value because it was limited to line of sight. But for close to two years, these boats and the intrepid sailors who manned them put to sea almost every day. They went out in all weather except in winter, when the bay had frozen over. If the prospect of confrontation with well-armored German warships in a February nor'easter off Fire Island worried the crews of these boats, no record of it exists.

Section Base 5 got its first real test in the early winter of 1918 when a German submarine laid a string of moored contact mines not far from the Fire Island Lightship (LV-68). LV-68 lay at anchor some nine miles south of Fire Island and forty miles east of New York Bay, smack in the middle of the busy commercial shipping lanes. Roosevelt's men spent almost two weeks in frigid weather assisting a squadron of U.S. Navy minesweepers and elements of the coast guard in clearing, dissecting and destroying these mines.

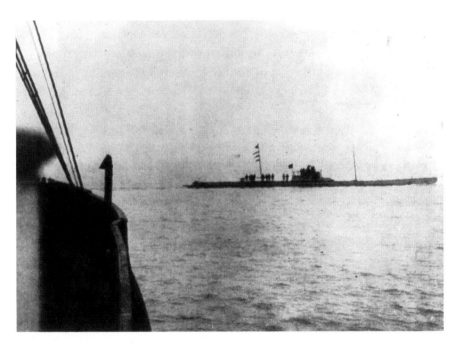

A German submarine on the surface three hundred meters off the starboard bow. *Photo courtesy of the Library of Congress.*

While the minesweepers broke the mines free of their mooring cables, Section Base 5 and coast guard personnel captured the floating mines and carefully brought each one up on Fire Island's beaches. It was not a safe or easy job. Each German Hertz horn mine—characterized by its sensitive, protruding spikes—carried a charge of hundreds of pounds of TNT.

Once on dry sand, Ensign Suydam and at least one of his machinist's mates assisted two experts from the U.S. Navy Mine Sweeping Division in taking the mines apart to study and record details of the advanced German design. The technical intelligence they gathered assisted the U.S. Navy in improving the allied forces' future mine warfare capabilities. Finally, the men safely burned the hundreds of pounds of TNT from each mine, completing the entire process without suffering any personnel casualties.

The second major test for Roosevelt's Splinter Fleet sailors came on July 19, 1918, when at 11:23 a.m. the five-hundred-foot long cruiser USS *San Diego*, on her way to New York with more than 1,100 men on board, was believed to have been struck by a German submarine-laid mine. The noise from the explosion was so loud that the residents of Point O'Woods reported hearing it plainly. Three men died in the explosion, three more died abandoning ship: one was killed when a lifeboat fell on him, another was crushed by a falling smoke stack and the third became trapped at his lookout post in the crow's nest. Another three men were seriously injured in the process of fleeing the doomed ship. Within only twenty-three minutes, the fourteen-year-old flagship had gone under, about eleven miles southeast of Fire Island Inlet.

Because the explosion of the mine had knocked out the ship's power, an SOS could not be sent, so Captain Harley Christy dispatched a small boat to Point O'Woods to seek help. Two hours after the sinking, the small boat crashed through the surf at Point O'Woods.

By early afternoon Section Base 5 had received word from Point O'Woods that the *San Diego* had suffered a serious explosion southeast of Fire Island Inlet and that help was needed. Ensign Suydam immediately dispatched his three patrol boats to the scene. He then took a few of his men with him to Point O' Woods to direct rescue operations from there.

By the time Suydam and his sailors got to Point O' Woods in late afternoon, they found thirty-one officers and men from the *San Diego* who had managed to make it to shore in two lifeboats. The thirty-one were taken back to West Sayville, fed, provided with clothing and sent by automobile to Reserve Fleet

Headquarters in New York City. The remainder of the *San Diego*'s officers and men were plucked from the ocean by a variety of larger vessels and transported to the naval facility at Hoboken, New Jersey. The *San Diego* was the only major U.S. warship lost in World War I.

The base's three boats patrolled throughout the night, looking for any additional survivors and succeeded in rescuing one downed pilot from the Bay Shore Naval Air Station. He had been helping in the search for survivors, but his plane had become disabled, and he was forced to ditch.

The armistice was signed in November 1918, but the Splinter Fleet continued to patrol the waters around Fire Island for several more months. Finally, in April 1919, after two years of dedicated service, West Sayville's Section Base 5 was abandoned. The sailors of the Splinter Fleet returned to their regular jobs. The *Nemesis* was returned to her owner, while the *Sunbeam* and the *See W. See* were sold at auction.

In something of a sad twist of nautical fate, men involved in the rum-running business purchased Roosevelt's yacht *Sunbeam*. About one year later, while bringing a cargo of illicit liquor down the Niagara River, she struck some rocks during a pursuit by law enforcement. The crew escaped, but the *Sunbeam* was stuck fast. The rotting hull of the once beautiful yacht turned warship remained derelict on the banks of the Niagara until at least the 1930s before disappearing forever.

Chapter 14

BAY SHORE AND ITS
NEAR-FORGOTTEN HEROES

U.S. naval aviation officially came to Bay Shore on May 4, 1917, when the commandant of the First Naval District ordered the U.S. Navy to take over from the Naval Militia of the State of New York eight acres of land in the heart of south Bay Shore. The property, part of a small peninsula just west of today's Bay Shore marina, remains bounded on the west by Lawrence Creek, on the south by the Great South Bay and on the east by a shallow inlet. The New York Naval Militia had organized the location only one year earlier for the purpose of training naval volunteers in flying and aviation mechanics.

On May 17, 1917, the navy officially commissioned the property as United States Naval Air Station, Bay Shore—arguably the nation's second such facility with the original built in January 1914 in Pensacola, Florida. On June 6, 1917, Lieutenant A.C. Read, USN, took over as commanding officer of the new facility, marking the transition of the base from the supervision of the New York State Naval Militia to the direct control of the United States Department of the Navy.

Less than two months prior to opening NAS Bay Shore, on April 6, 1917, Congress declared war against the Imperial German government. At that time, the U.S. Navy and Marine Corps combined had but 1 naval air station; 48 pilots, including student pilots; 239 enlisted men; 54 airplanes; 1 airship; and 3 balloons. While the navy had recognized for years the potential importance of naval air power, little had been done to promote it. With the onset of war, the need for naval air power became overwhelming and immediate. Planes and aviators were urgently needed both in the United States and in Europe to patrol for German submarines, reconnoiter German positions, engage German aircraft and complete other combat-related assignments.

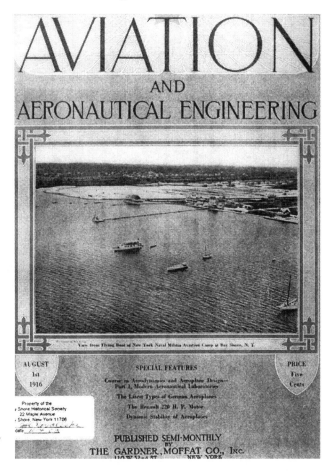

The New York Naval Aviation Militia Camp property in 1916, which became NAS Bay Shore. *Photo courtesy of the Long Island Maritime Museum.*

In the spring of 1917, NAS Bay Shore had a complement of only four hydroaeroplanes, six naval officers and eighty-nine enlisted men. By the end of the war, the station had a complement of fifty-five officers and more than eight hundred enlisted men. The station also had some fifty buildings, including five hangars, a hospital, a copper and blacksmith shop, an ordnance building, a "bomb house," an oil reclaiming plant, an officers' club and a YMCA. The southern extreme of the property had one long runway parallel to the waterfront with five concrete extensions, about evenly spaced, running into the bay for the retrieval of the flying boats. For training flights, the planes used a circular flying course laid out just south of Bay Shore in the Great South Bay with a diameter of about three miles. At one point in 1918, the inventory of seaplanes reached sixty-four, including R-6s, N-9s

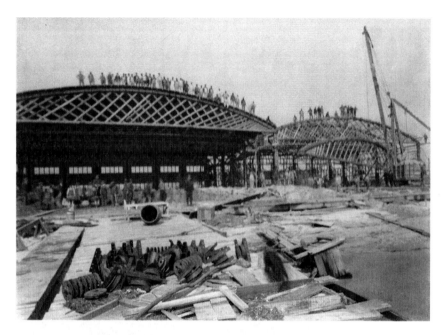

The construction of two of the base's primary hangars. They are facing south with the Great South Bay about fifty yards away. *Photo courtesy of the Long Island Maritime Museum.*

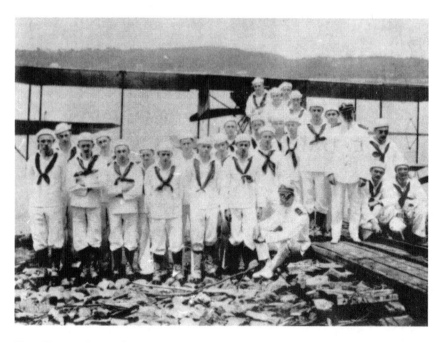

The officers and men of a unit that appears, even in their dress whites, to be responsible for getting aircraft in and out of the water. *Photo courtesy of the Long Island Maritime Museum.*

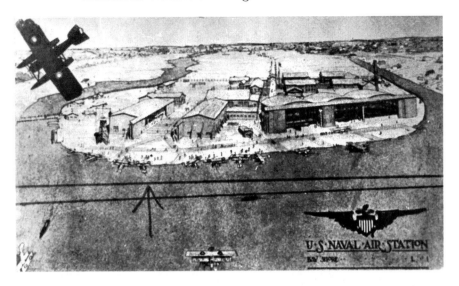

A depiction of the layout of NAS Bay Shore. *Photo courtesy of the Long Island Maritime Museum.*

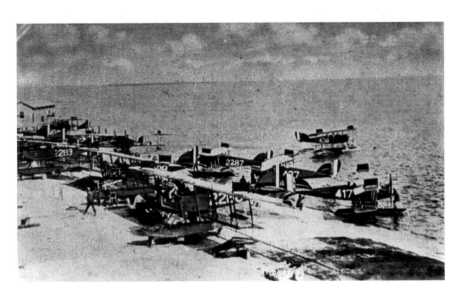

Naval aircraft being prepped for the morning flights. *Photo courtesy of the Long Island Maritime Museum.*

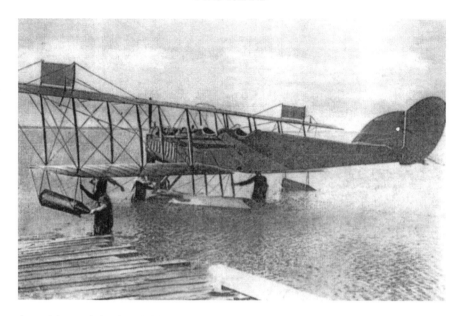

An aerial scout being handled by a crew of five enlisted men. *Photo courtesy of the Bay Shore Historical Society.*

and H- and F-series flying boats, all built from plans made by Glenn Curtiss and his Curtiss Aeroplane Company.

Like Glenn Curtiss, the man who owned the property on which the navy built NAS Bay Shore was a multitalented engineer and patriot. The wealthy Charles Lanier Lawrance had trained as an architect but found his calling as an aviation inventor. It was Bay Shore's Lawrance who came up with the revolutionary air-cooled aircraft engine design when water-cooled engines had been the standard.

Lawrance went on to design the predecessors to the Wright Whirlwind aircraft engines. These engines enabled the famous long-distance flights of Admiral Byrd, Amelia Earhart, Charles Lindbergh and others. But despite the great fame brought to Byrd, Earhart and Lindbergh, Lawrance remained relatively unknown. He liked to describe his lack of public recognition with, "Who remembers Paul Revere's horse?"

By the late summer of 1917, NAS Bay Shore formed two squadrons, the Thirteenth and the Fourteenth, both of which conducted the flight training necessary to qualify a man as a navy pilot. After qualifying, the new pilots went to Pensacola for advanced training and then transfer to combat units in Europe or the United States. Training for the aviation technicians followed

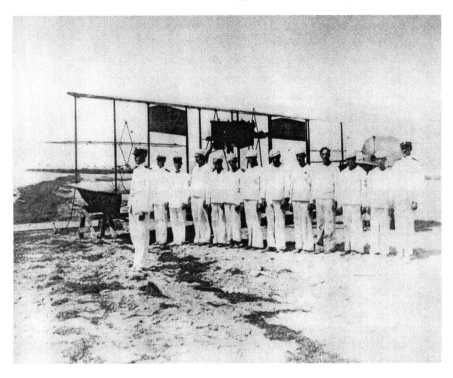

Officers and enlisted men prepared for inspection at NAS Bay Shore. *Photo courtesy of the Bay Shore Historical Society.*

a similar path. By the time of the signing of the armistice on November 11, 1918, NAS Bay Shore had trained 1,000 men, a remarkable number given that the entire navy had a grand total of 48 pilots and 239 enlisted men only nineteen months before!

Naval aviation training is by its nature a dangerous business, and Bay Shore saw its share of accidents. However, the machines were slow and lightweight, so that the chances of surviving a crash, especially in the shallow waters of the Great South Bay, were pretty good. One such accident was described in a short piece written in May 1919 by an individual for the *War Record of the Town of Islip*:

> *A student went into a nosedive at 4,000 feet; at 2,000 feet the machine started to go on its back, the position in which it landed, striking the water with terrific speed and at an angle of about fifteen degrees, upside down. The crew of the speedboat (a small, fast craft manned during*

flights to perform rescues) had observed the accident and shoved off. The speedboat was 200 yards from the dock and under full sail when the plane hit the water. The student was removed from the wreck in exactly one minute from the time the plane hit, having suffered more from shock than anything else.

The same writer mentions that not all training crash victims were so fortunate; three deaths occurred at NAS Bay Shore as a direct result of crashes during flight training. The *New York Times* of May 5, 1918, described the outcome of one of those crashes. The article read in part as follows:

Ensign T. Spencer Alden, 25 years old, a flying instructor, was killed and Philip P. Mooser, 24 years old, a student aviator was severely injured when they lost control of their hydroaeroplane over the Great South Bay. Eight other hydroaeroplanes from NAS Bay Shore were also in the air over the Bay near the Fire Island Inlet and witnessed the accident. The pilots landed on the water near where the wreckage was floating and swam to it finding both men pinned in the wreckage at a depth of about five feet. They finally succeeded in bringing both bodies to the surface and placed them in a launch that had arrived from the station.

The *Times* article reported, "Just as the body of Ensign Alden was being carried from the launch to the training station, a man and a woman arrived from the land side. They were Mr. and Mrs. Alden, father and mother of the Ensign, who had just arrived from Ft. Wayne, Ind., to see their son, and had gone at once to his training station. They were overcome with grief." The *Times* article concluded, saying, "A naval funeral in honor of Ensign Alden will be held at the station on Monday morning at 9 a.m."

Describing another incident, the *New York Times* of July 12, 1918, reported that Chief Quartermaster William Fraser Beham—who had received his commission as an ensign only two weeks before, but who had not yet been formally notified—was killed in a five-hundred-foot fall into the waters of the Great South Bay. Beham had been flying solo for the past two weeks, and on this day, he was over the Great South Bay when something happened and his plane started a slow circling descent. No one watching was alarmed until the plane settled silently into the water. A number of civilians went out in their motorboats and, with some difficulty, pulled Beham's body out from

A broken concrete apron is all that is left to mark the location of the Bay Shore Naval Air Station. *Photo courtesy of Elaine Kiesling Whitehouse.*

under the motor where it was caught. The coroner had determined that Beham had been unable to get out of his plane and had died from drowning. The article concluded saying that Beham was survived by his mother, Ellen Beham, three sisters and a brother, all of whom resided at the time at 480 Tenth Street in Brooklyn.

Pilots stationed at NAS Bay Shore also engaged in what were called emergency patrols. In World War I, German submarines and the technologically advanced mines they could lay posed a substantial threat to the heavily traveled shipping lanes into and out of New York harbor. Bay Shore Naval Air Station and its smaller sister naval base, the U.S. Naval Reserve Force Section Base 5 in West Sayville, received tasking to protect those sea lanes.

The U.S. Naval Air Station Bay Shore officially closed on May 19, 1919, almost precisely two years after its commissioning. It had done its job. Its first commanding officer, A.C. Read, later wrote:

I am referring to the unusual attitude of friendliness, cordiality and cooperation of the civilian residents of the city (of Bay Shore) and certain civilian organizations. I regret the necessity of saying "unusual," but it is a fact that communities in the vicinity of naval stations regard them as a rule, as necessary evils, the merchants furnishing the exception to prove that rule. But at Bay Shore it was quite different. The attitude of treating the personnel as men of honor, defenders of our country, and the intense interest displayed along practical lines benefited the station immeasurably, not only in material matters, such as the building and equipping of a fine dispensary as a single illustration, but in improving the morale of the whole station.

Today the property on which NAS Bay Shore stood reveals no trace of the heroic efforts made by the dedicated men who lived, trained and died there. There is no park, no preserved artifact, no monument—not even a small sign or plaque to say that this land was ever populated by anything but the luxurious private homes that occupy it today.

USS NORTHERN PACIFIC AND THE
HEROES OF FIRE ISLAND

At about 2:20 a.m. on New Year's Day 1919, the 526-foot long troop transport ship USS *Northern Pacific*, with more than 3,000 people aboard, went hard aground on the inner bar about a mile and a half east of the Fire Island Lighthouse and just west of Ocean Beach. According to the *New York Times* account, the ship had been going at "moderate" speed—probably somewhere between twelve and eighteen knots—when at high tide she bounced over the outer bar and came to rest broadside on the inner bar. The ocean waves broke steadily on the ship's superstructure, as all desperate attempts to back her off proved fruitless. Of the 3,000 people in danger, approximately 2,500 were U.S. soldiers returning from the European campaign, with 269 of these bedridden sick and wounded and 1,475 sick and wounded but ambulatory.

Despite the ship's close proximity to the lighthouse beacon, sea and weather conditions at the scene were such that initial reports said the ship's lookouts could not make out even a glimmer of light through the fog, spray and wind-driven rain until it was too late.

Soon after the grounding, in water less than half her normal draft and at a distance of only about 300 yards from the shore, the ship's commander, Captain L.J. Connelly, USN, sent an SOS to his headquarters. The navy wasted no time in dispatching the 413-foot cruiser *Columbia* (C-12) and numerous escort vessels, including a second cruiser, at least a half-dozen destroyers, a troop transport ship, two hospital ships and several tugs, to the sight of the grounding. U.S. coast guardsmen from Oak Island, Point O' Woods, Lone Hill and as far east as the Blue Point Life Saving Station also took to the beach to try to launch their boats to approach the wreck, but the

strong south–southeast wind and resulting crashing waves were too much, even capsizing some of the small beach-based rescue craft.

That morning, lifesaving crews tried several times to get a line across to the stranded vessel. With a line aboard, a breeches buoy could be set up to bring men to shore. But conditions, including the shifting of the big ship on the bar, prohibited success.

By midmorning, senior army and navy officials were becoming desperate for information on the status of the stranded ship and her human cargo. They also wanted to know more about the prospects for getting a lifeline set up between the ship and the rescuers on shore. The military decided to ask the commanding officer of the U.S. Naval Air Station in Bay Shore to reconnoiter the situation.

That same morning, Lieutenant Commander B.N. Chase climbed into his Curtis HS-1 flying boat, a single engine coastal patrol biplane, and headed south. According to the *New York Times*, Chase quickly located the stranded

A composite photo of actions taken during the rescue operation. In the lower left a plane from NAS Bay Shore is seen flying low over the ship. The pilot is probably Lieutenant Commander B.N. Chase, the commanding officer of NAS Bay Shore. *Photo courtesy of the Long Island Maritime Museum.*

ship and, in less-than-perfect flying weather, proceeded to make inspection runs at very slow speeds at an altitude of less than fifty feet above the ship's decks. Chase considered dropping a lifeline to the ship and then dropping the other end of the line to the rescuers on shore but ultimately decided against the risky idea, apparently at the request of the commanding officer of the *Northern Pacific*.

Landing back in Bay Shore at about 3:00 p.m., Chase reported what he had found. He told reporters that the fleet of rescue ships stood about a half mile off shore unable to get close enough to render assistance. Chase added that he and other navy pilots stood ready, should the situation warrant, to get lines aboard to rig breeches buoys and start getting men ashore.

Meanwhile, a rescue launch dispatched by the cruiser *Columbia* was in distress, becoming unmanageable when her propeller hit something and shattered its blades. With makeshift oars, the crew of seven tried to keep the stricken boat headed into the wind, but the waves proved too big and powerful. As the sailors struggled, the boat drifted steadily toward the bar. It struck and began to fill with water when a large wave rolled the launch over, throwing all seven men into the sea. The sailors clung to the overturned boat, but immersed in cold water, hypothermia set in, and they could not

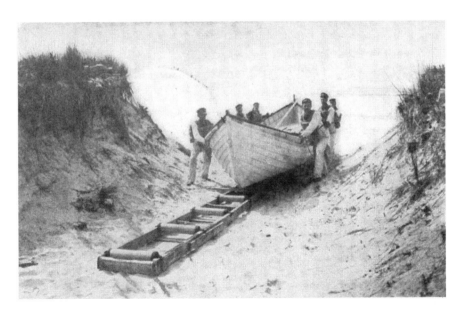

Surfboat crew returning with their boat. *Photo courtesy of Judy Stein and Ken Stein.*

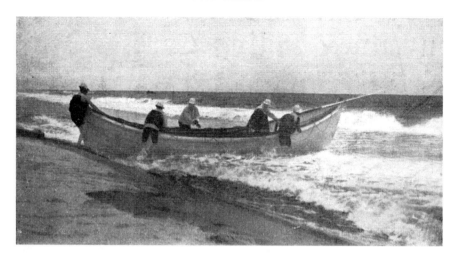

Surfboat crew launching their boat in the surf. *Photo courtesy of Judy Stein and Ken Stein.*

survive for long. The rescue crews on shore could only watch in despair as the men would soon succumb and as sea conditions continued to preclude the launching of a surfboat.

Later that week, a local paper reported that as so often happens in such *in extremis* situations, the emergency produced the man. This time the hero was Roy Arnott, a man known along the Fire Island beach as a skilled bay man, dock builder and powerful swimmer.

In what seemed but an instant, while everyone else stood frozen in the sand, Arnott tied one end of a surf man's line around his waist, ran to the water's edge and jumped into the churning sea. He powered his way as far as he could on foot and then disappeared headfirst into the roiling waves.

Local news reports indicated that the crowd on shore stood uniformly aghast at what they believed to be a totally reckless and foolhardy deed, the needless wasting of yet another precious life. The paper reported that some yelled as loudly as they could against the roar of the surf, "Come back, Roy. It's a fools chance!"

Arnott ignored the pleas, and with powerful strokes and the inhuman strength that can come from desperation, he breasted the big waves, hardly seeming to gain but making headway just the same. Finally reaching the overturned boat and the seven slowly dying men, Arnott found some of them bruised and bleeding from being pounded against the gunwales of the boat. All were fighting the waves and the cold to stay afloat. Arnott quickly

made his surf line fast to the boat while men on shore pulled the other end taught. He then got each man to grab hold of the rope and slowly make his way, hand over hand, toward shore. Arnott brought up the rear, the last man to make it to the beach.

A reporter for a local newspaper said that the men on shore had underestimated both Arnott's strength and his determination. The reporter wrote that one of the lifesaving crew who witnessed the rescue told him, "That was the nerviest piece of work I've ever seen in all my life." The reporter added, "And those fellows aren't given to slopping over." Arnott apparently was as modest and unassuming as he was strong and courageous. The same local reporter appeared to find satisfaction in writing that a newsman from a major New York City paper, who had rushed up to Arnott for his name and comments, was brushed aside by the hero with a brief "Sorry, but I'm only a beachcomber."

But the rescue was not over, and beachcomber Roy Arnott and navy lieutenant commander Chase before him would not be the only remarkable heroes in this daring effort to preserve life.

By later in the day, the experienced and persistent Fire Island–based coast guardsmen had managed to get a couple of lines securely established between the grounded vessel and the shore and initiated a breeches buoy rescue effort. The rescuers also secured a second line that they attached to a lifeboat, such that a line ran from one end of the lifeboat to the ship and from the other end of the lifeboat to the beach. A run was made out to the stricken ship but came back without any passengers.

Twenty-four hours later, by the early afternoon of Thursday, January 2, Captain Charlie Baker, recently retired but who for many years had commanded the Point O' Woods crew, succeeded in getting aboard the ship and returning with a number of wounded men. During the remainder of the afternoon, the surfboats made repeated trips. But on the eleventh trip, near disaster would strike again.

On the eleventh crossing, Baker's boat made it to the ship and took on more soldiers. But suddenly, about halfway back to shore, a large wave caused the boat to breech. She soon rolled over in the large waves, throwing her five lifesavers and twelve soldiers into the rough cold waters.

Some, like sixty-year-old Baker, were able to swim to shore. But others were less able. Men began throwing their arms madly into the air and crying for help while some just quietly sank into the waves.

Yet again a terrible situation created unexpected heroes. No sooner had the lifeboat gone over than Lieutenant John P. Roullet, a military aviator who had come to the beach to help out where he could, dove into the water. Joining him were two U.S. Navy sailors who just happened to be on leave and who had come to the site. They were Seaman First Class Bert Collins, a native of Sayville, and Seaman Second Class John Vanderveer, from Patchogue.

Roullet and Collins soon reached the overturned boat, with each man taking two men in tow, moving them slowly back to shore. But Vanderveer spotted a sailor caught in a rip current, a deadly flow of water pushing him

Female volunteers helping the rescuers with hot coffee and sandwiches. *Photo courtesy of the Long Island Maritime Museum.*

steadily farther out to sea. Roullet swam after the man, eventually catching him and then dragging him unconscious out of the rip and safely to shore. The individual whose life he saved was A. LeRoy Carter, a chief petty officer assigned to the Lone Hill station.

Others who managed to make it to shore on their own were also on the verge of unconsciousness. The rescue teams cut their clothes off, rolled them in warm blankets and later transported them to the facilities at the Bay Shore Naval Air Station to recover. Miraculously, no one had lost his life.

Eventually everyone made it safely off the grounded ship, with most taken by launches from the assisting fleet of navy vessels. However, the Fire Island rescuers had brought some 250 men ashore via their breeches buoy or by surfboat or by hand.

Just before 9:00 p.m. on January 18, salvage workers on three tugs were able to refloat the USS *Northern Pacific* after having removed her four six-inch guns, ammunition and other heavy gear. She underwent months of repairs before returning to service, making two more trips to Europe before retiring in mid-August 1919. In late August, the ship was decommissioned and sold for commercial use. However, while under tow to a Pennsylvania shipyard, she caught fire and was lost forever.

Chapter 16

FIRE ISLAND'S FLYING SANTA

On December 17, 1953, Santa flew over the Fire Island Lighthouse and delivered gifts to the people living there. How did this happen?

Probably no one can recall any instance of a ship's captain or a plane's pilot stopping by to thank a single lighthouse keeper for guiding his or her safe return home. But once there was such a man, and while he passed away many years ago, his tradition of recognizing selfless service as epitomized by the lighthouse keepers' lives on to this day. Every December, members of the Fire Island Lighthouse Preservation Society take one day to honor this man and the people he served with a reenactment of what he did and why.

It all began more than eighty years ago, in December 1929, with a Maine floatplane pilot by the name of William Wincapaw. Penobscot Bay–area natives knew Wincapaw as a skilled pilot, competent in most weather conditions. He flew a variety of aircraft, but he could be found most often in floatplanes, flying close to the water's surface and around the coast's numerous rocks and islands. On many occasions, he took to the air in treacherous weather conditions to provide transport for the sick or injured in remote locations, saving many lives. For these risky flights, lighthouse beacons along the coast often became his only aids to navigation. His personal appreciation of the lighthouse keepers' work and their dedication to keeping these lights burning grew stronger each time he had to make a flight in poor weather conditions.

Impressed with the keepers' dedication, Captain Wincapaw took to landing at several of the local lighthouses, spending time to personally thank the keepers. But he came to believe that a mere thank-you was not enough and that something special should be done to show them how much he and others appreciated their lifesaving efforts.

Inspired by the spirit of Christmas, on December 25, 1929, Wincapaw packed up a dozen packages, each containing newspapers, magazines, coffee, candy and other everyday mainland items, and loaded them onto his plane. While hardly expensive luxuries, Wincapaw thought the small items could make life on an isolated island or remote location just a little more bearable. He took to the air, flew over the lights in the Rockland area and carefully dropped these modest gifts to the surprised lighthouse families below.

The packages and the small items inside, not to mention the style of delivery, deeply touched the lighthouse keepers and their families. Wincapaw's small gesture of thanks made Christmas Day all the more special for the residents of these isolated outposts. When Wincapaw later came to realize how much his Christmas flight had meant to his lighthouse friends, he vowed to continue, including more of the lighthouse families and coast guard stations up and down the coast.

Wincapaw's flights continued, expanding into Massachusetts, Rhode Island and Connecticut. Wincapaw's son, Bill Jr., soon joined his father on his Yuletide lighthouse trips. Not long after the second Christmas flight, the lighthouse families began to call the Wincapaws the Flying Santas. Accepting the awarded moniker, Captain Wincapaw began to dress for the role, donning white whiskers, red hat and all. Some said he occasionally worried a child or two when his beard, caught by the wind, accompanied his packages to the ground, but for the most part, all went smoothly.

By 1933, the Wincapaw family had relocated to Winthrop, Massachusetts. From Winthrop, their Christmas flights took them to as many as ninety-one lighthouses and coast guard stations. Along with the greater number of visits, the cost of the program expanded significantly. Fortunately, the Wincapaws found willing sponsors in the local business community, enabling them to continue their beloved Santa missions.

Around 1934, Bill Jr. introduced his father to Edward Rowe Snow, one of his teachers at Winthrop High School. By 1936, Captain Wincapaw needed additional help with his growing schedule of flights and tapped Mr. Snow to do the job. Mr. Snow, a descendant of early American sea captains, would eventually become a noted maritime author and historian. He wrote more than one hundred publications, primarily about New England's coastal history including *Pirates and Buccaneers of the Atlantic Coast* (1944), *The Lighthouses of New England* (1945), *Mysteries and Adventures along the Atlantic Coast* (1948), *True Tales of Pirates and Their Gold* (1957) and *Supernatural Mysteries and Other Tales* (1974).

In 1938, Captain Wincapaw began a job in South America, and for the next few years, he had difficulties making the Santa Claus drops. The younger Wincapaw and Mr. Snow took over and continued the Santa missions without a hitch. By 1940, the younger Wincapaw also had to give up his spot on Santa's flying sleigh, so Snow and his wife, Anna-Myrle, took over.

But the onset of World War II brought the holiday flights almost to an end. October 1941 found Bill Jr. on his way to Naval Air Station Pensacola to become a flight instructor for the navy, and Mr. Snow joined the Army Air Corps as a bomber pilot. In late 1942, First Lieutenant Snow was wounded in a bombing mission over Northern Africa. He spent Christmas in the hospital, with his body recuperating but with his mind on the lighthouse families that would have no visit from their Flying Santa that year.

The wounds Snow suffered forced him to be discharged from the army in early 1943. Then, as Christmas approached and with wartime restrictions still in place, Mr. Snow made plans to visit his lighthouses by automobile and boat. But fortune chose to smile on Mr. Snow. A U.S. government pilot heard a radio interview with Snow, during which Snow described how he planned to continue the Flying Santa missions by boat with no aircraft available. Just before Christmas, the army's Boston Fighter Wing and the Civilian Aeronautics Administration combined to arrange for Snow to continue the flights. That year the flying Santa Claus could again visit lighthouses from Maine to Cape Cod.

The year 1946 brought the Wincapaws back from their war duties, with the father and son rejoining Mr. Snow in delivering the Christmas packages. By now, the number of lighthouses and coast guard stations they visited had grown to 115, spread out from Massachusetts to the Canadian border. It required two days of flying to make the rounds.

But tragedy would strike on July 16, 1947. Captain Wincapaw, only sixty-two years old, suffered a heart attack shortly after taking off from Rockland Harbor. His seaplane nose-dived into the water, and both he and his passenger were killed. Three days later, Rockland-area lighthouse keepers, their families, island residents and representatives of the coast guard, navy and army held a memorial service. As the service began, foghorns and lighthouse-warning bells rang out across Penobscot Bay in memory of Captain William H. Wincapaw, the original Flying Santa of the lighthouses.

Mr. Snow vowed to carry on the Flying Santa tradition even if he could not fly his own aircraft. He believed the cost of hiring a pilot and plane for

the lighthouse flights would be well worth the expense. Snow and his wife decided that the money they invested in the Christmas flights provided an excellent return—plenty of fun and a great deal of personal satisfaction. The deep appreciation they got from the lighthouse families made it all worthwhile. Later the U.S. Coast Guard alleviated some of the costs by providing the Snows with an aircraft to make at least some of his deliveries.

On December 17, 1953, Snow made his first and only Flying Santa visit to the Fire Island Lighthouse. That year he also conducted a transcontinental Santa flight, delivering packages to lighthouses on the East Coast in the morning and in California and Oregon in the evening. By 1954, he had expanded his range of visits to lighthouses in the Great Lakes, Bermuda and even remote Sable Island, far off the coast of Nova Scotia.

In 1981, Mr. Snow suffered a stroke, and for the first time since 1942, could not make his Santa Claus mission. To the rescue came the Hull Lifesaving Museum and other New England–based institutions and a gentleman by the name of Ed McCabe who volunteered to become the new Flying Santa. In 1982, Mr. Snow passed away.

In the ensuing years, the Flying Santa program continued thanks primarily to the members of the Hull Lifesaving Museum, including McCabe, Mr. Ben Blake and Mr. George Morgan. But by 1987, the Flying Santa visited only fifteen lighthouses, primarily due to the automation of so many facilities and the end of the lighthouse keeper era. Then the program began to recover with more flights made to lighthouses serviced by coast guard stations.

In 1997, a small group of Flying Santa supporters formed an organization aptly named the Friends of Flying Santa, Inc., located in Stoneham, Massachusetts. The idea came about to try to make certain that there would always be sufficient money to ensure that the Flying Santa tradition would continue. The group held fundraisers, raffles, arranged helicopter tours of the lighthouses, sponsored boat cruises and even overnight stays at some of the lighthouse facilities. They printed a newspaper, established a website and developed a Flying Santa logo that embellished all sorts of gift items they sold.

As mentioned above, Mr. Snow's 1953 Christmas flight was the only visit of the Flying Santa to the Fire Island Lighthouse. The lighthouse keeper at that time—and the last keeper of the Fire Island Lighthouse—was Mr. Gottfried Mahler. The Fire Island Lighthouse Preservation Society has been fortunate to have both Mr. Mahler and his wife, Marilyn Mahler, as regular guest speakers, describing what life was like as keepers, including the 1953 Christmas drop.

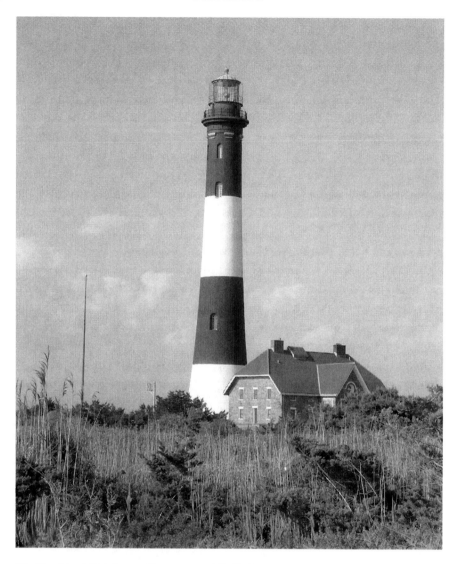

The Fire Island Lighthouse. *Photo courtesy of Joe Lachat.*

December 2009 brought the eightieth anniversary of Captain Wincapaw's first Flying Santa visit, which was celebrated at the Fire Island Lighthouse with a flyby visit by Santa. Everyone involved, from Fire Island Lighthouse Preservation Society members to official Friends of the Flying Santa to casual observers, were proud to be part of the tradition of honoring those who serve on our coasts.

BIBLIOGRAPHY

Bailey, Paul. *Long Island: A History of Two Great Counties, Nassau and Suffolk.* New York: Lewis Historical Publisher, Inc., 1949.

Caplan, Bruce M. *The Sinking of the Titanic.* Seattle, WA: Seattle Miracle Press, 1997.

Dickerson, Charles P. *A History of the Community of Sayville.* East Patchogue, NY: Searles Graphics, Inc., 1975.

Edwards, Clarissa. *A History of Early Sayville.* Sayville, NY: Suffolk County News Press, 1935.

Field, Van R. *Mayday! Shipwrecks, Tragedies & Tales from Long Island's Eastern Shore.* Charleston, SC: The History Press, 2008.

Forester, Frank. *Sporting Scenes and Sundry Sketches: Being the Miscellaneous Writings of J. Cypress, Jr. Vol. 1.* New York: 1842.

Gonzalez, Ellice B. *Storms, Ships & Surfmen: The Lifesavers of Fire Island.* Fire Island, NY: Eastern National for the Fire Island National Seashore and the National Park Service, 1982.

Havemeyer, Harry W. *East on the Great South Bay: Sayville and Bayport 1860–1960.* Mattituck, NY: Amereon Ltd., 2001.

———. *Fire Island's Surf Hotel and Other Hostelries on Fire Island Beaches in the Nineteenth Century.* Mattituck, NY: Amereon Ltd., 2006.

Homberger, Eric. *The Historical Atlas of New York City.* New York: Henry Holt and Company, 1994.

Howell, Nathaniel R. *Islip Town's World War II Effort.* Islip, NY: Buys Brothers, 1948.

Johnson, Madeleine C. *Fire Island 1650s–1980s.* New Jersey: Shoreland Press, 1983.

Philbrick, Nathaniel. *In the Heart of the Sea: The Tragedy of the Whaleship Essex.* New York: Penguin Group, 2000.

Rattray, Jeanette Edwards. *Discovering The Past: Writings of Jeanette Edwards Rattray 1893–1974 Relating to the Town of East Hampton.* Suffolk County, NY: Newmarket Press, 2002.

Shaw, Edward Richard *Legends of Fire Island Beach and the South Side.* New York: 1895.

———. *The Pot of Gold: A Story of Fire Island Beach.* New York: 1888.

Taylor, Lawrence J. *Dutchmen on the Bay: The Ethnohistory of a Contractual Community.* Philadelphia: University of Pennsylvania Press, 1983.

Thompson, Benjamin F. *History of Long Island.* New York: 1839.

Tornoe, Johannes K. *Early American History, Norsemen Before Columbus.* Oslo, Norway: Univeritetsforlaget, 1964.

Tredwell, Daniel M. *Personal Reminiscences of Men and Things on Long Island.* Brooklyn, NY: 1912.

Newspapers, Magazines and Journals

Brooklyn Daily Eagle
Columbian
East Hampton Star
Fire Island Tide Newspaper
Long Island Forum
Newsday
New York Herald Tribune
New York Times
Suffolk County News

Websites

Atlas Obscura, Atlasobscura.com.

Captain William Kidd, captainkidd.org.

Friends of Flying Santa, flyingsanta.com.

Naval History and Heritage Command, www.history.navy.mil.

NavSource Naval History, navsource.org.

"World Heritage Convention," United Nations Educational, Scientific and Cultural Organization, http://whc.unesco.org/en/35/.

ABOUT THE AUTHOR

Jack Whitehouse grew up on the South Shore of Long Island, becoming a regular visitor to Fire Island's Cherry Grove and Fire Island Pines beginning in the early 1950s. In 1955, he took his first sailing lesson on the Great South Bay, eventually teaching sailing for the Wet Pants Sailing Association in the early 1960s.

Following graduation from Brown University, in 1968 Jack received his commission as an ensign in the United States Navy. From 1968 to 1971, he served aboard the destroyer USS *Buck* (DD-761) for two deployments to Vietnam. In 1971, he became the executive officer and then the commanding officer of the patrol gunboat USS *Chehalis* (PG-94). In the early 1970s, Jack became the first U.S. Navy exchange officer with the Royal Norwegian navy. In 1974, he qualified as an officer of the deck (underway) on a Norwegian warship. He served with the Norwegian navy for a total of twenty months in frigates, patrol boats and submarines in waters north of the Arctic Circle.

In 1976, Jack joined the U.S. Foreign Service, serving abroad for most of his career. In 1995, he and his wife, Elaine Kiesling, and son, John, returned to the South Shore where he and Elaine make their home today.

Jack wanted to write *Fire Island: Heroes & Villains on Long Island's Wild Shore* after completing research for his earlier book, *13 Legends of Fire Island and the Great South Bay*, a work of historical fiction. He discovered that the true-to-life history of the beach is as enthralling as any work of fiction.

Jack is also the author of *Sayville Orphan Heroes, the Cottages of St. Ann's*. He writes for *Fire Island Tide Newspaper* and lectures on both the history of Fire Island and the Church Charity Foundation orphanage once located in Sayville. In 2010, he won the first-place award from the Press Club of Long Island for his regular column in the *Fire Island Tide Newspaper*.

Visit us at
www.historypress.net